in his own words

Andy Warhol

Mike Wrenn

OMNIBUS PRESS
LONDON · NEW YORK · SYDNEY

Copyright © 1991 Omnibus Press
(A Division of Book Sales Limited)

Edited by Chris Charlesworth
Format designed by Ranch Associates
Art Direction Lisa Pettibone
Cover and book designed by Monica Chrysostomou
Artwork by Luke Wakeman
Picture research by Paul Giblin
Typesetting & co-ordination by Caroline Watson

ISBN 0.7119.2590.7
Order No. OP46119

Exclusive distributors:

Book Sales Limited,
8/9 Frith Street,
London W1V 5TZ, UK.

Music Sales Corporation,
225 Park Avenue South,
New York, NY 10003, USA.

Music Sales Pty Ltd.,
120 Rothschild Avenue,
Rosebery, NSW 2018, Australia.

To the Music Trade only:
Music Sales Limited,
8/9 Frith Street,
London W1V 5TZ, UK.

Picture credits:

All photographs supplied by Camera Press Ltd., The Hulton Picture Library, The Kobal
Collection, LFI, Pictorial Press, Rex Features, Starfile and Topham.

Every effort has been made to trace the copyright holders of the photographs in this book but one or
two were unreachable. We would be grateful if the photographers concerned would contact us.

Typeset by Capital Setters, London.
Printed in Tiptree, Essex by Courier International Limited.

Introduction

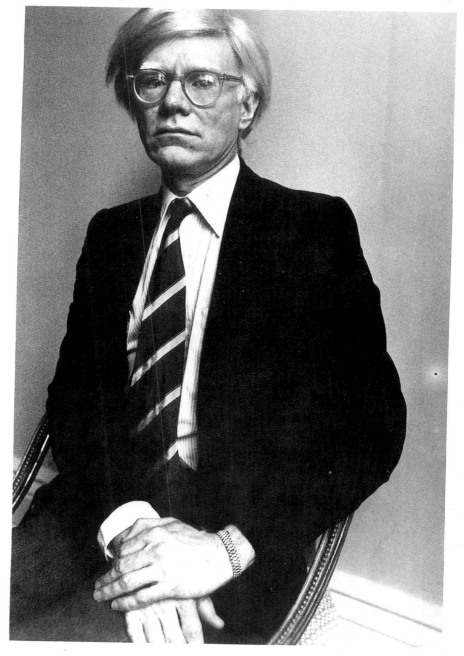

I don't think my art has any lasting value.

Introduction

Andy Warhol's birth date is a debatable issue. There never was a certificate, although it's widely accepted that August 6, 1928 is as good a guess as any.

The third son of Julia and Andrei Warhola, a Rusyn couple who had emigrated to America from a small Ruthenian village (in their day still part of the Austro-Hungarian empire), Andy was born and raised in the depression-hit suburbs of Pittsburgh.

Demonstrating early signs of artistic talent, the self-conscious youngster was encouraged by schoolteachers and supported by his family, in what would become the inevitable pursuit of an artistic career – in New York City.

Immediately successful as an illustrator, Andy fuelled his own frustrations as a fine artist however, by rapidly gaining a reputation as a *commercial* one. The two weren't compatible in pre-sixties America, so Andy's only way into the galleries, would be to *make* the art dealers take notice.

As we now know, it was pop art that would do the trick – the Coke bottles, the Marilyns, the Disaster prints, the Brillo boxes and, of course, the Campbell's soup cans, which would become his trademark – all being mass-produced by a team of mostly unpaid assistants at his New York studio, The Factory.

By 1961, Warhol had become the first art world celebrity since Dali and Picasso, but while socialites were dropping his name at every chic gathering from New York to Paris, Andy was dropping art.

A long-term diversion into film was the immediate goal but, fairly swiftly, Warhol began switching his talents to theatre (with his infamous *Plastic Exploding Inevitable* show) and music (through the support and promotion of The Velvet Underground, arguably modern America's most innovative band).

Ironically though, whereas the artist's silk-screened transference of 'people into products' had earned him acclaim in the galleries (well, in some of them), a similar process in cinematic terms would only provoke increasing bouts of hostility towards the film-maker – culminating, as it did, in an ugly assassination attempt in 1968.

Surviving to spend the rest of his days in a corset – during which time he launched his own magazine and TV show – Warhol died unexpectedly in hospital on February 22, 1987, following a routine gall-bladder operation.

Fourteen months later, Sotheby's held an auction of the late artist's artefacts – lovingly collected by one of life's compulsive shoppers. The New York sale-room expected about 600 bidders,

but 6,000 turned-up. They anticipated taking around $10 million, but instead they hauled-in over $25 million. When a cookie jar went for $40,000, reporters may have been entitled to remark, "That takes the biscuit." But when Andy's white porcelain urinal fetched $70,000, nobody would be taking *anything* for granted ... His paintings, of course, would start to make millions.

So where does that leave Andy Warhol – collectable fraud, or artistic genius? The art world has never *really* been able to make up its mind. Indeed, when *Warhol's Stable Show* was presented at Elinor Ward's New York gallery in November 1962, William Seitz bought a Marilyn for $250 on behalf of the city's Museum of Modern Art. Blissfully unaware of the fact, his colleague Peter Seltz remarked, "Isn't it the most ghastly thing you've ever seen in your life?" To which Seitz is supposed to have replied, "Yes, isn't it. I bought one."

During the filming of *Lonesome Cowboys*.

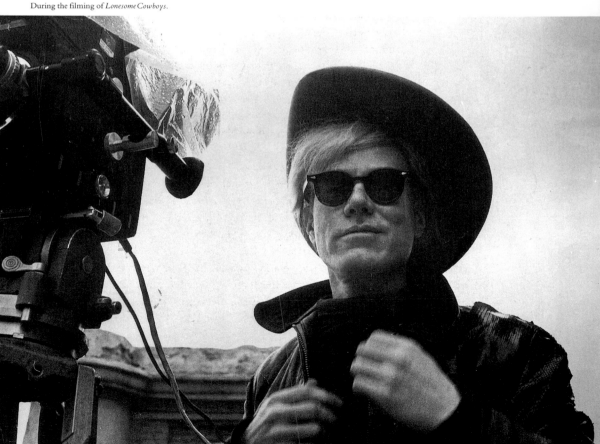

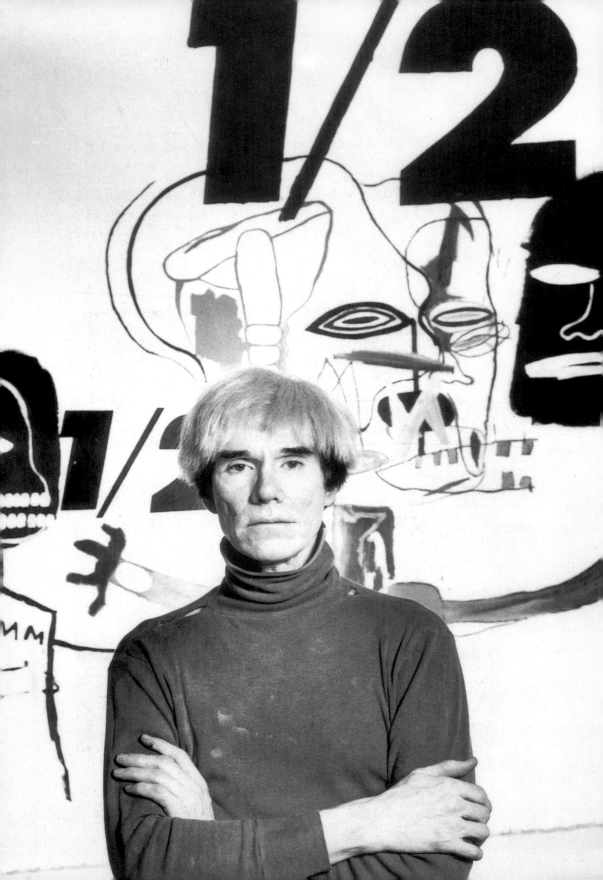

Andy Warhol

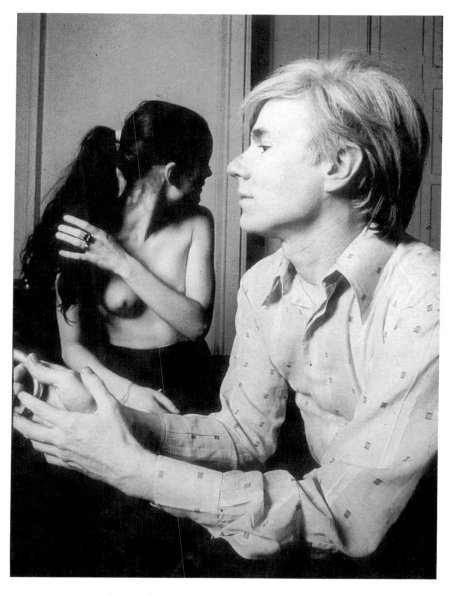

I feel very much a part of my times, of my culture, as much a part of it as rocket ships and television.

1928-1987 *In conversation:*

Interviewer: Why did you put a naked woman on a red sofa in the middle of one of your jungle pictures?
Andy: I needed a bit of red there.

I'd prefer to remain a mystery. I never like to give my background and, anyway, I make it all up different every time I'm asked. It's not just that it's part of my image not to tell everything, it's just that I forget what I said the day before, and I have to make it all up over again.

Our mother taught that she liked going to church better than material things. She never believed in being wealthy, she believed just being a real good person made her happy. I think religion formed Andy's character. The way we were brought up never to hurt anybody, to try to do everything right, to believe that you're just here for a short time and to build up your treasures and your spiritual things because you are going to leave the material things behind.
John Warhola, brother.

Mom used to make tin flowers out of old fruit cans – that's the reason I did my first tin-can paintings. You take a tin can, the bigger the better, like the family ones that peach halves come in, and I think you cut them with scissors. It's very easy, and you just make flowers out of them. My mother always had lots of cans around, including the soup cans. She was a wonderful woman and a real good and correct artist, like the primitives.

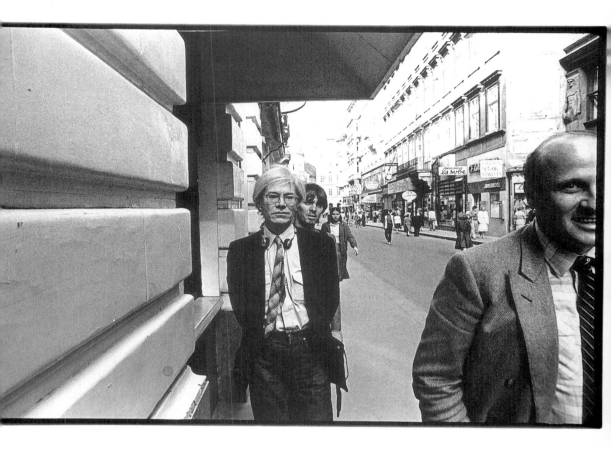

I was always sick as a child, and had to keep going to summer school to catch up ... I was weak and I ate too much candy.

A more talented person than Andy Warhol I never knew. He was magnificently talented. Personally not attractive, and a little bit obnoxious, he had no consideration for other people. He lacked all the amenities. He was socially inept at the time and showed little or no appreciation for anything. He was not pleasant with the members of his class, or with any of the people with whom he associated. Maybe he was withdrawn because of his lack of social background, and developed the approach to cover. But he did seem to have a goal from the very start. You weren't conscious of what it was, but he stayed right with it.
Joseph Fitzpatrick, childhood art teacher.

I never wanted to be a painter. I wanted to be a tap dancer.

I loved going to the movies and I probably hoped that the movies showed what life was like. But what they showed was so different from anything I knew about, that I'm sure I never really believed it – even though it was probably nice to think that it was all true and that it would happen to me some day. It's the movies that have really been running things in America ever since they were invented. They show you what to do, how to do it, when to do it, how to feel about it, and how to look how you feel about it. Everybody has their own America, and then they have the pieces of a fantasy America that they think is out there but they can't see.

I had a job one summer in a department store looking through *Vogue*s and *Harper's Bazaar*s and European fashion magazines for a wonderful man named Mr Vollmer. I got something like 50 cents an hour and my job was to look for 'ideas'. I don't remember ever finding one or getting one. Mr Vollmer was an idol to me because he came from New York and that seemed so exciting. I wasn't even thinking about ever going there myself though.

I (started working) in display, and I did some advertising paintings that were used in the window of Bonwit Teller's, and they left there to go into a gallery, and after that, I dunno, I just met so many interesting people and then met other interesting people ...

When I came to New York City I took a bus from Carnegie-Mellon, and this wonderful lady in *Glamour* magazine named Tina Fredericks just said that, when I get out of school she would give me a job. So I went back to her, got a free-lance job, and then spent all day looking for more free-lance jobs – and did my work at night. I never did anything, except work.

I kept living with room-mates, thinking we could become good friends and share problems, but I'd always find out that they were just interested in another person sharing the rent. At one point I lived with 17 different people in a basement apartment on 103rd and Manhattan Avenue, and not one person of the 17 ever shared a problem with me. I worked very long hours in those days, so I guess I wouldn't have had time to listen to any of their problems even if they had told me any, but I still felt left out and hurt.

I used to come home and be so glad to find a little roach to talk to. It was so great to have at least someone there to greet you, and then just go away.

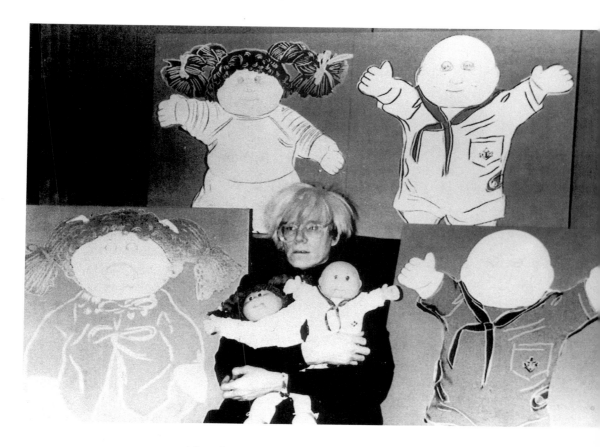

A lot of people in the industry began to notice Andy's magazine work. Whatever he illustrated – shampoo, bras, jewellery, lipstick or perfume – there was a decorative originality about his work that made it eye catching … The childish hearts and flowers and the androgynous pink cherubs that he used were not quite what they seemed to be, there was a slight suggestiveness about them that people in the business recognised and approved. He could kid the product so subtly that he made the client feel witty.
Calvin Tompkins, writer.

I used to go around all the galleries in the late fifties, usually with a good friend of mine named Ted Carey. Ted and I had both wanted to have our portraits done by Fairfield Porter, and we'd thought that it would be cheaper if he painted us in tandem, and then we could cut it apart and each take half. But when he'd posed us, he sat us so close together on the couch, that we couldn't slice a straight line between us and I'd had to buy Ted out.

I never wanted anything. Even when I was 20 and hoped that maybe one day I would be a success and very famous, I didn't think about it.

More than anybody I ever met, Andy Warhol wanted to meet celebrities. He really had a passion for success and for famous people.
George Klauber, contemporary at the Carnegie Institute of Technology.

I knew Truman Capote in the fifties, in my pre-Pop days. I wanted to illustrate his short stories so badly, I used to pester him with phone calls all the time – till one day his mother told me to cut it out. It's hard to say now what it was that made me want to connect my drawings with those short stories. Of course they were wonderful, very unusual – Truman was a pretty unusual character himself – they were all about sensitive boys and girls in the South, who were a little bit outside society, and who made up fantasies for themselves. I could almost picture Truman tilting his head and arranging his words around the paper, making them go together in a magical way that put you in a certain mood when you read them.

Backstage with video director Don Letts at the Clash gig.

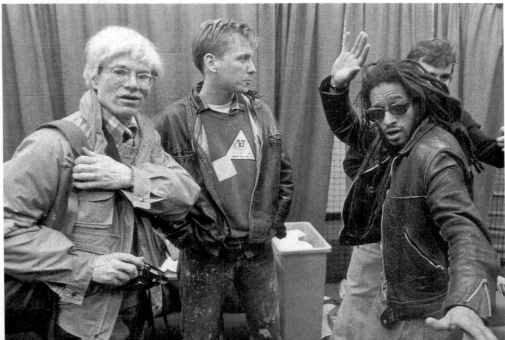

th Lana Turner.

I met Andy Warhol in 1958 through Tina Fredericks. I realised early that he knew the answer to every question he asked. The first day I met him, he said, "Tina tells me you know everything. How did World War One begin?" ... I really felt when I first knew Andy that he was the greatest voyeur I ever met. He was an incredibly intelligent person, extraordinarily incisive. Santayana once defined intelligence as the ability to see things as they are quickly. That's precisely what Andy had.
Emile de Antonio, agent.

I got paid well for my commercial art, and did anything I was told to do. If they told me to draw a shoe, I'd do it, and if they told me to correct it, I would – I'd do anything they told me to – correct it and do it right. I'd have to invent, and now I don't. After all that 'correction', those commercial drawings would have feelings, they would have a style. The attitude of those who hired me had feeling, or something to it. They knew what they wanted, they insisted, sometimes they got very emotional. The process of doing work in commercial art was machine-like, but the attitude had feeling to it.

With Grace Jones and Keith Haring at a New York AIDS benefit.

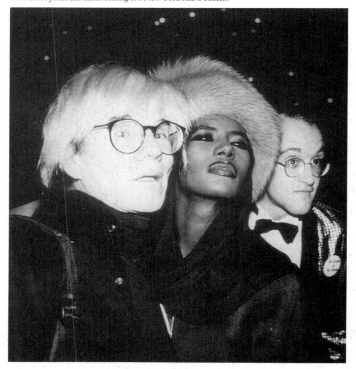

The person I got my art training from was Emile de Antonio.
When I first met De, I was a commercial artist. In the sixties De
became known for his films on Nixon and McCarthy, but back in
the fifties he was an artists' agent. He connected artists with
everything from neighbourhood movie houses, to department
stores and huge corporations ... He was the first person I know of
to see commercial art as *real* art, and real art as *commercial* art, and
he made the whole New York art world see it that way too ... I
worked at home in those days. My house was on four floors,
including a living area in the basement where the kitchen was, and
where my mother lived with a lot of cats – all named Sam.

Andy said, "I want to be Matisse ..." There was a wonderful
photograph of Matisse by Cartier-Bresson at that time in *Vogue* or
Harper's Bazaar. What interested Andy in Matisse was not so much
his work, as the fact that Matisse had reached a point where all he
had to do was tear out a little piece of paper, and glue it to another
piece of paper, and it was considered very important and valuable.
It was the fact that Matisse was recognised as being so world-
famous, and such a celebrity that attracted Andy. This was, I
thought, the key to his whole life.
Charles Lisanby, friend.

Whatever I do, and do machine-like, is because it is what I
want to do.

The things I want to show are mechanical. Machines have less
problems.

Andy did everything for money. His main goal was to learn how
to do everything faster.
Ralph Ward, friend.

I wanted to be an art businessman or a business artist. Being good
in business is the most fascinating kind of art.

Business art is a much better thing to be making than art art,
because art art doesn't support the space it takes up, whereas
business art does. If business art doesn't support its own space, it
goes out of business.

*Whatever I do, and do machine-like, is because it is
what I want to do.*

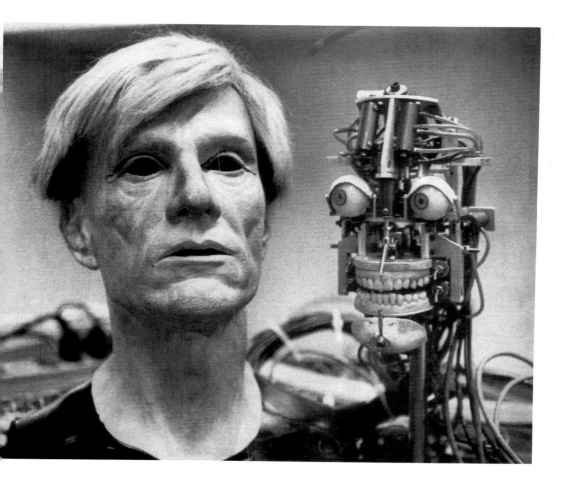

Andy said, "I'm starting pop art." I said, "Why?" He said, "Because I hate abstract expressionism."
Leonard Kessler, contemporary at the Carnegie Institute of Technology.

The pop artists did images that anybody walking down Broadway could recognise in a split-second. Comics, picnic tables, men's trousers, celebrities, shower curtains, refrigerators, Coke bottles – all the great modern things that the abstract expressionists tried so hard not to notice at all.

All I need is tracing paper and a good light. I can't understand why I was never an abstract expressionist because, with my shaking hand, I would have been a natural.

By 1960, when pop art first came out in New York, the art scene here had so much going for it, that even all the stiff European types had to finally admit we were a part of world culture.

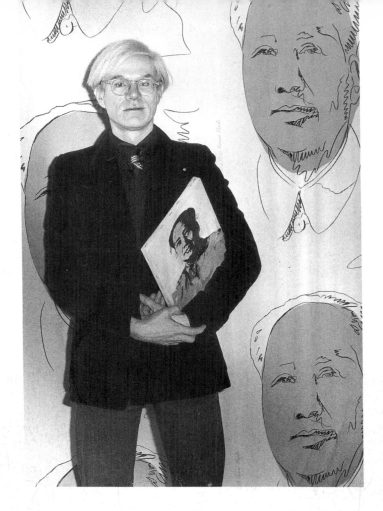

The further west we drove (on his way to California) the more 'pop' everything looked on the highways. Suddenly we all felt like insiders because, even though pop was everywhere – that was the thing about it, most people still took it for granted, whereas we were dazzled by it – to us, it was the new art. Once you 'got' Pop, you could never see a sign the same way again. The moment you label something, you take a step – I mean, you can never go back again to seeing it unlabelled. We were seeing the future and we knew it for sure. We saw people walking around in it without knowing it, because they were still thinking in the past, in the references of the past. But all you had to do was know you were in the future, and that's what put you there. The mystery was gone, but the amazement was just starting.

Whenever he had come to me before, I had been very enthusiastic and said, "Oh great, let's do a show." But when he came to me with his early pop paintings, I wasn't for them. He said, "If you don't think they're good and if you're not interested in them, I'll take them elsewhere."
David Mann, art dealer.

I've often wondered why people who could look at incredible new art and laugh at it, bothered to involve themselves with art at all. And yet you'd run into so many of these types around the art scene.

I can't tell you what pop art is, it's too involved. It's just taking the outside and putting it on the inside, or taking the inside and putting it on the outside – bringing the ordinary objects into the home. Pop art is for everyone. I don't think art should be only for the select few, I think it should be for the mass of American people, and they usually accept art anyway. I think pop art is a legitimate form of art like any other, impressionism etc. It's not just a put on.

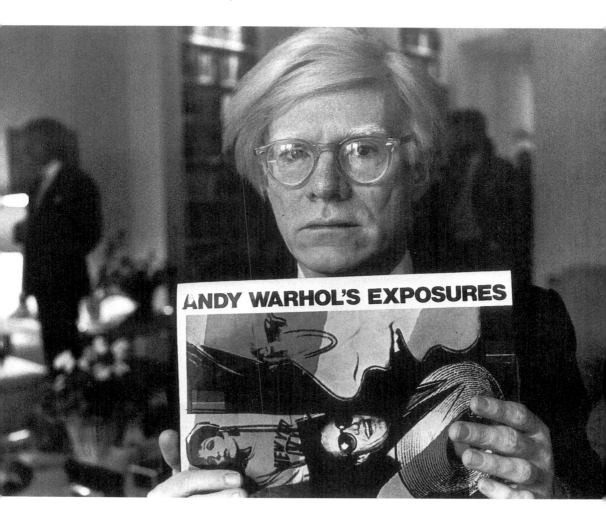

I like boring things. I like things to be exactly the same over and over again.

A lady friend of mine asked me, "Well, what do you love most?" That's how I started painting money.

Pop art is liking things.

I really like comic strips ... Well, I like the colours and the balloons. I think people should always talk with balloons over their heads.

If you look at something long enough, I've discovered, the meaning goes away.

I've been quoted a lot as saying, "I like boring things." Well, I said it and I meant it. But that doesn't mean I'm bored by them. Of course, what I think is boring must not be the same as what other people think is, since I could never stand to watch all the most popular action shows on TV, because they're essentially the same plots and the same shots and the same cuts over and over again. Apparently, most people love watching the same basic thing, as long as the details are different. But I'm just the opposite. If I'm going to sit and watch the same thing I saw the night before, I don't want it to be essentially the same – I want it to be *exactly* the same. Because the more you look at the same exact thing, the more the meaning goes away. And the better and emptier you feel.

Warhol's serial photo silk-screens of Marilyn Monroe are about as sentimental as Fords coming off the assembly line, each one a different colour, but each one the same as any other ... What happens to the idea of originality with the advent of mass production, or to the idea of the unique artifact? As with the computer, there is only the abstract program and the 'hard' print-outs it can reproduce infinitely. It is perhaps because of such factors that (some critics) insist that pop art represented America's first real break with European tradition, and, one might speculate, a final and irreversible one.
Ron Sukenick, writer.

The importance people attach to the things an artist uses is irrelevant.

With Joan Collins.

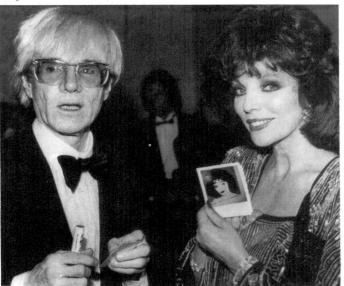

I don't feel I'm representing the main sex symbols of our time in some of my pictures, such as Marilyn Monroe or Elizabeth Taylor. I see Monroe as just another person. As for whether it's symbolic to paint Monroe in such violent colours – it's beauty, and she's beautiful, and if something's beautiful it's pretty colours, that's all. Or something.

I did meet Marilyn Monroe, at a party. I thought she was really great. Her movie image was quite different from her personal image though. She was quite quiet.

I wouldn't have stopped Monroe from killing herself. I think everyone should do whatever they want to do.

People love disasters.

The Marilyns and Campbell's soup cans are pretty and decorative, but the car crashes don't work because you can't have them in your living-room.
John Giorno, friend.

You'd be surprised how many people want to hang an electric chair on their living-room wall. Specially if the background colour matches the drapes.

When you see a gruesome picture over and over again, it doesn't really have any effect.

The death series I did was divided into two parts. The first on famous deaths, and the second on people nobody ever heard of – and I thought that people should think about them sometime. The girl who jumped off the Empire State building, or the ladies who ate the poisoned tuna fish, and people getting killed in car crashes. It's not that I feel sorry for them, it's just that people go by and it doesn't really matter to them that someone unknown was killed, so I thought it would be nice for these unknown people to be remembered by those who, ordinarily, wouldn't think of them.

I was never embarrassed about asking someone, literally, "What should I paint?" – because pop comes from the outside, and how is asking for ideas any different from looking for them in a magazine?

It was Henry Geldzahler who gave me the idea to start the Death and Disaster series. We were having lunch one day at Serendipity on East 60th Street, and he laid the *Daily News* out on the table. The headline was '129 DIE IN JET.' And that's what started me on the death series – the car crashes, the disasters, the electric chairs … Whenever I look back at that front page, I'm struck by the date – June 4, 1962. Six years – to the date – later, my own disaster was the front page headline, 'ARTIST SHOT'.

Each (Disaster) painting took about four minutes, and we worked as mechanically as we could, trying to get each image right, but we *never* got it right. By becoming machines, we made the most imperfect works. Andy embraced his mistakes. We never rejected anything. Andy would say, "It's part of the art." He possessed an almost Zen-like sensibility, but to the critics Andy became an existentialist because the accidents were interpreted as being intentional statements … I was with Andy 24 hours a day at that time, and I know that he would never choose an image for the kind of reasons that the critics dug up.
Gerard Malanga, assistant.

My paintings never turn out the way I expect them to, but I'm never surprised.

Artists are never intellectuals, that's why they're artists.

I'm not the High Priest of pop art, just one of the workers in it.

One of the phenomenal things about pop painters, is that they were already painting alike when they met.

When I have to think about it, I know the picture is wrong. And sizing is a form of thinking, and colouring is too. My instinct about painting says, "If you don't think about it, it's right." As soon as you have to decide and choose, it's wrong. And the more you decide about, the more wrong it gets. Some people sit there thinking about it because their thinking makes them feel they're doing something. But my thinking never makes me feel I'm doing anything. Leonardo da Vinci used to convince his patrons that his thinking time was worth something – worth even more than his painting time – and that may have been true for him, but I know that my thinking time isn't worth anything. I only expect to get paid for my 'doing' time.

The less something has to say, the more perfect it is.

I like empty walls. As soon as you put something on them they look terrible.

Warhol was a serious artist whose posture was unserious ... The implications of his ideas are still unfolding on post-modernism. **William Rubin, chief curator of painting and sculpture at the Museum of Modern Art in New York.**

I am a mass communicator. Ordinary people like my paintings. It took intelligent people years to appreciate the abstract-expressionist school, and I suppose it's hard for intellectuals to think of me as art.

Intellectuals are a bore.

I was a great admirer of Andy's because everyone was making fun of his Campbell's soup cans, and I thought they were what the United States deserved. I considered him the Voltaire of the United States. I felt they were really a *coup d'état*. **Taylor Mead, underground movie star.**

I've never been touched by a painting. I don't want to think.

I read an article on me once that described my machine-method of silk-screen copying and painting – "What a bold and audacious solution, what depths of the man are revealed in this solution!" What does that mean?

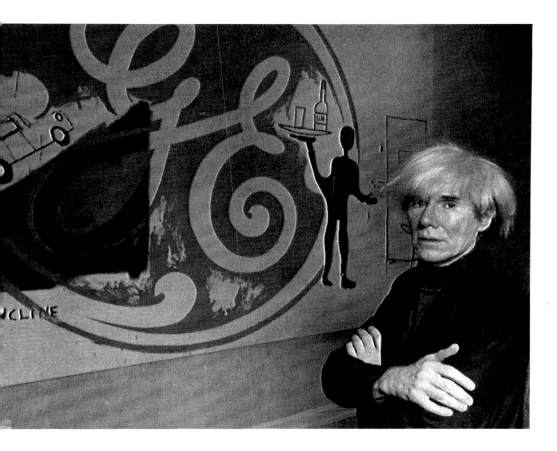

I tried doing (the silk-screen prints) by hand, but I find this way it's easier. This way I don't have to work on my objects at all.

Every painting is the same painting. The subject (be it Taylor, Kennedy or Monroe) is not significant.

I wanted to paint nothing. I was looking for something that was the essence of nothing, and the soup can was it.

Even when the subject is different, people always paint the same painting.

Somebody should be able to do all my paintings for me ... so that no one would know whether my picture was mine or somebody else's.

I think every painting should be the same size and the same colour. That way they're all interchangeable and nobody thinks they have a better painting or a worse painting.

I think it would be terrific if everybody was alike.

Don't think about making art, just get it done. Let everyone else decide whether it's good or bad, whether they love it or hate it. While they're deciding, make even more art.

Friends of Andy occupy a table in the back room at Max's Kansas City: Including International Velvet (Susan Bottomly), Paule McDonnevedieu, Viva (Susan Hoffman), Brigid Polk.

No matter how good you are, if you're not promoted right, you won't be remembered.

Don't talk to everyone. Be aloof.

Warhol was the person who created 'attitude'. Before Warhol, in artist circles, there was 'ideology' – you took a stance against the crassness of American life. Andy Warhol turned that on its head, and created an attitude. And the attitude was ''It's so awful, it's wonderful. It's so tacky, let's wallow in it.'' That still put you above it, because it was so knowing. It placed you above the crassness of American life, but at the same time you could enjoy it … pop art absolutely rejuvenated the New York art scene. It did for the galleries, the collectors, the gallery goers, the art-minded press, and the artists' *incomes,* what The Beatles did for the music business at about the same time. Avant-gardism, money, status, le chic, and even the 1960s idea of sexiness – it all buzzed around pop art.

Tom Wolfe, critic.

Everyone's always asking me how much I get paid for this and that, and thinking I'm a millionaire. I'm really not a millionaire, I never have any money … It's all the dealers and everything that get all the bread. I'm just sick of it. I'm constantly attacked by the Internal Revenue Bureau, it's so silly. I just get by, but I can't complain … I'm comfortable, I have hot and cold running water.

People ask me if I'm shocked that people pay thousands of dollars for one of my paintings. Well … why should I be shocked? I think it's wonderful.

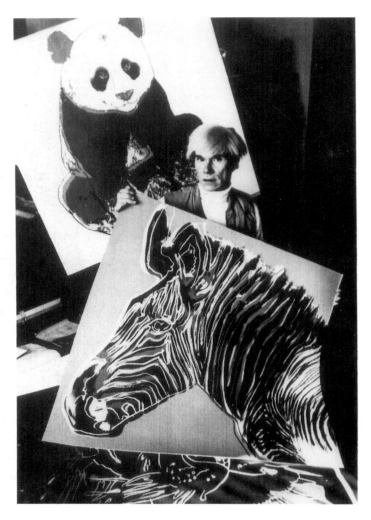

My painting's just about entertaining people. I'm surprised it's lasted so long.

All painting is fact, and that is enough. The paintings are charged with their very presence. The situation, physical ideas, physical presence – I feel this is the whole comment.

Wasted space is any space that has art in it.

In conversation:

Interviewer: Would you mind if nobody was looking at your Coke bottles in 50 years' time?
Andy: No, besides … I painted them in cheap paint which'll probably drop off the canvas before then.

I liked the flowers because they looked like a cheap awning.

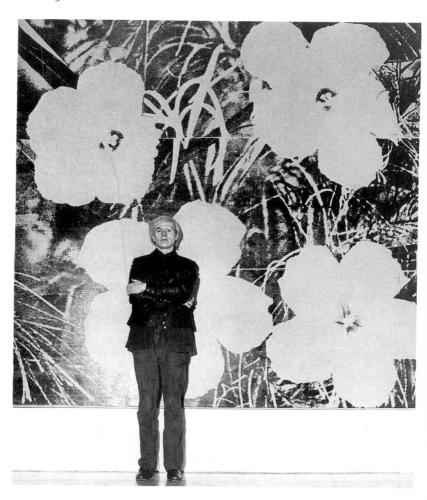

(In 1971) I specifically chose to exhibit my flower paintings in France ... because I thought the French would like flowers, what with Renoir and so on.

He always tried recklessly to outdo himself.
Roy Lichtenstein, artist.

I get jealousy attacks all the time. I think I may be one of the most jealous people in the world. My right hand is jealous if my left hand is painting a pretty picture.

The most striking opening of the period was definitely Andy's *Brillo Box Show*. You could barely get in, and it was like going through a maze. The rows of boxes were just wide enough to squeeze your way through.

Robert Indiana, artist.

How did the Brillo boxes come about? Well ... I'd done all the Campbell's soup cans in a row on a canvas, and then I got a box made to do them on a box – but that looked funny because it didn't look real ... I had the boxes already made up though. They were brown and looked just like boxes, so I thought it would be great just to do an ordinary box.

I really don't care. I think with some of the important things happening, they must have more to worry about than some dumb little boxes.

(When questioned about an official ruling that his current exhibition did not constitute 'art', and would therefore be subject to regular import duties.)

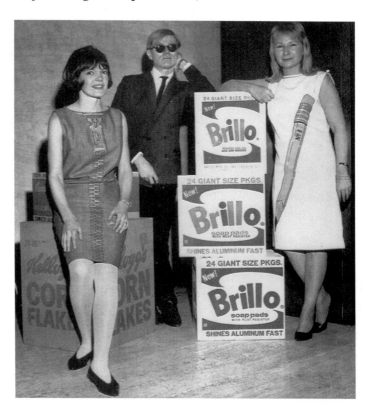

With Robin McDonald (left) and Jane Wagner, showing his work 'Brillo' at New York's Four Seasons in 1965.

With Jane Forth (left) and Ultra Violet (Isabelle Collin-Dufresne).

To my mind this has put paid to The Tate as an art gallery.
**Uniformed attendant at Andy's 1971 Tate exhibition, as
featured in the film, *But The People Are Beautiful*.**

I think of myself as an American artist. I like it here, I think it's so
great. It's fantastic. I'd like to work in Europe, but I wouldn't do
the same things. I feel I represent the US in my art, but I'm not a
social critic. I just paint those objects in my paintings because those
are the things I know best.

Andy is the greatest businessman I know. He's also got a lot of sex
appeal, but he doesn't use it. He's too busy with his business.
Jude Jade, seventies aide.

I'm just doing work. Doing things. Keeping busy. I think that's
the best thing in life – keeping busy.

My philosophy is that every day's a new day. I don't worry about
art or life. I mean, war and the bomb worry me, but usually
there's not much you can do about them. Money doesn't worry
me either, though I sometimes wonder where is it? Somebody's
got it all!

I suppose I have a really loose interpretation of 'work', because I
think that just being alive is so much work at something you don't
always want to do. Being born is like being kidnapped, and then
sold into slavery. People are working every minute, the machinery
is always going. Even when you sleep.

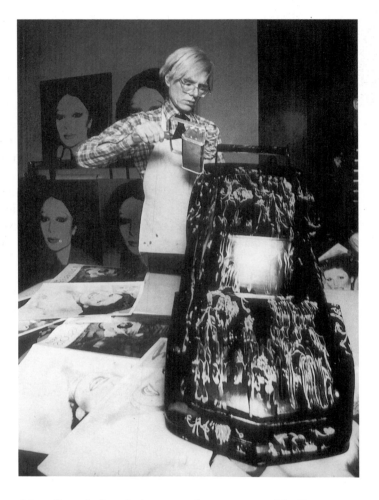

A lot of people thought it was me that everyone at The Factory was hanging around, that I was some kind of big attraction that everyone came to see, but that's absolutely backward. It was me who was hanging around everyone else. I just paid the rent, and the crowds came simply because the door was open. People weren't particularly interested in seeing me, they were interested in seeing each other. They came to see who came.

I never have time to think about the real Andy Warhol, I'm just so busy … not working, but busy playing, because work is play when it's something you like.

In conversation with David Bailey:

In conversation with David Bailey:
David: Why have you stopped painting?
Andy: I haven't stopped painting. I paint my nails, I paint my eyes, every day.

Sometimes, when I'd got to The Factory early, there would be Andy hard at work on a silk-screen. I'd ask him why he was working so hard and he'd say, "Somebody's got to bring home the bacon." Then he'd look at me and say, "How many songs have you written today?" I'd lie and say "Two" … Andy was incredibly hard-working and generous. He was the first to arrive for work at The Factory and the last to leave. And then he would take us all to dinner. He gave everyone a chance. When he told me I should start making decisions about the future, and what could be a career, I decided to leave him. He did not try to stop me, legally or otherwise. He did, however, tell me that I was a rat. I think it was the worst word he could think of.
Lou Reed, The Velvet Underground.

You never had to buy things in the sixties. You could get almost anything for free. Everything was 'Promotion'. Everybody was pushing something, and they'd send cars for you, feed you, entertain you, give you presents – that's if you were invited. If you weren't invited, things would run about the same, only they wouldn't send the car.

The pop idea was that anybody could do anything.
So naturally, we were all trying to do it all.

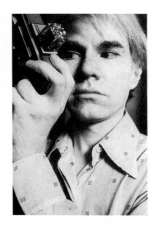

I like making movies, because it's easier than painting paintings.

Although I didn't buy a movie camera till sometime in '63, it had certainly occurred to me to be a do-it-yourself film-maker long before then, probably because of De. His interest had already started to shift from art to movies around 1960.

Andy and I were great social climbers. We had this gimmick of approaching rich people at their apartments, to ask if we could use their places as locations for our movies. The dinner invitations flowed ...
Sam Green, lifelong friend.

I made my earliest films using, for several hours, just one actor on the screen doing the same thing – eating or sleeping or smoking. I did this because people usually just go to the movies to see only the star, to eat him up, so here at last is a chance to look only at the star for as long as you like, no matter what he does, and to eat him up all you want to. It was also easier to make.

The two girls I used most in my films, Baby Jane Holzer and Edie Sedgwick, are not representatives of current trends in women or fashion or anything. They're just used because they're remarkable in themselves.

What I was actually trying to do in my early movies, was show how people can meet other people, and what they can say to each other. That was the whole idea – two people getting acquainted. And then when you saw it, and you saw the sheer simplicity of it, you learned what it was all about. Those movies showed you how some people act and react with other people. They were like actual sociological 'for instance's. They were like documentaries, and if you thought it could apply to you, it was an example. And if it didn't apply to you, at least it was a documentary – it could apply to somebody you knew and it could clear up some questions you had about them.

My first films using the stationary objects were also made to help the audience get more acquainted with themselves. Usually when you go to the movies you sit in a fantasy world but, when you see something that disturbs you, you get more involved with the people next to you.

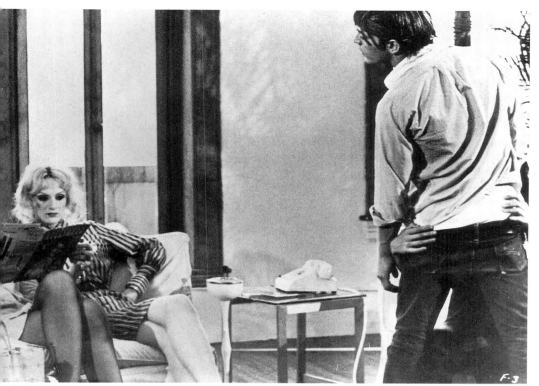

m the film *Flesh*.

n the film *Trash*.

If I ever have to cast an acting role, I want the wrong person for the part. I can never visualise the right person in a part. The right person for the right part would be too much. Besides, no person is ever completely right for any part, because a part in a role is never real. So if you can't get someone who's perfectly right, it's more satisfying to get someone who's perfectly wrong. Then you know you've really got something.

Andy wasn't doing experimental photography, he was experimenting with people. From the very beginning I could see that what he was doing was very interesting because it left the camera on human beings who were characters, and the basic ingredient of all dramatic fiction is character. It was very simple. Andy wanted films that weren't directed. I was able to provide the framework in which a film that was basically undirected, had some direction.
Paul Morrissey, director and Factory assistant.

They're experimental films. I call them that because I don't know what I'm doing.

All my films are artificial, but then everything is sort of artificial. The artificial fascinates me, the bright and shiny.

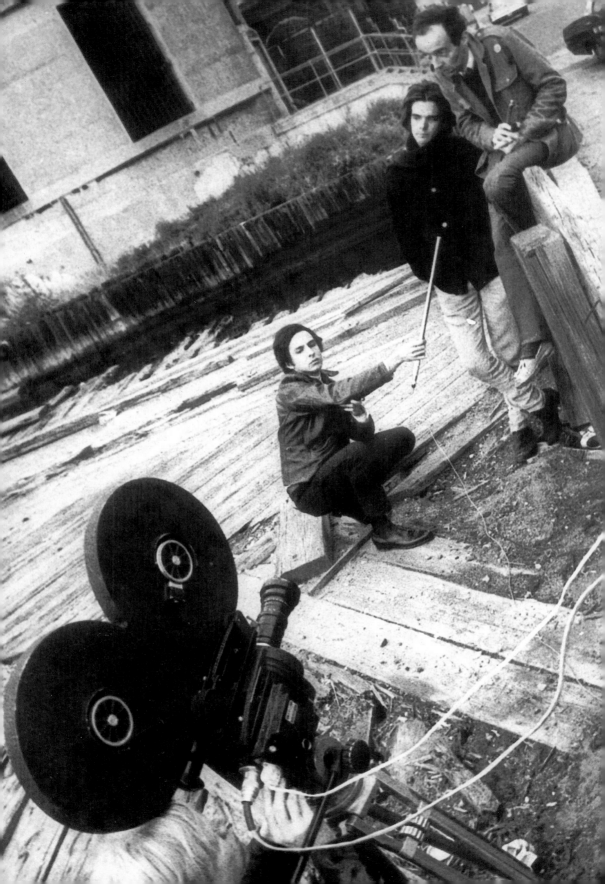

These movies are art!

Scripts bore me. It's much more exciting not to know what's
going to happen. I don't think plot is important. If you see a movie
of two people talking, you can watch it over and over again
without being bored. You get involved, you miss things – you
come back to it ... But you can't see the same movie over and over
again if it has a plot, because you already know the ending ...
Everyone is rich, everyone is interesting. Years ago, people used
to sit looking out of their windows at the street. Or on a park
bench. They would stay for hours without being bored, although
nothing much was going on. This is my favourite theme in movie-
making – just watching something happening for two hours or so
... I still think it's nice to care about people. And Hollywood
movies are uncaring. We're pop people. We took a tour of
Universal Studios in Los Angeles and, inside or outside the place,
it was very difficult to tell what was real. They're not real people
trying to say something. And we're real people not trying to say
anything. I just like everybody and I believe in everything.

With his artist's intuition as his only guide, he records – almost
obsessively – man's daily activities, the things he sees around him.
A strange thing occurs. The world becomes transposed,
intensified, electrified. We see it sharper than before ... A new way
of looking at things, and the screen, is given through the personal
vision of Andy Warhol. In a sense, it is a cinema of happiness.
Jonas Mekas, publisher of *Film Culture* magazine.

I like all kinds of films except animated films. I don't know why.

I don't have strong feelings about sadism and masochism. I don't
have strong feelings on anything. I just use whatever happens
around me for my (film) material. I don't collect photographs or
articles for reference material. I don't believe in it. I used to collect
magazine photographs for my paintings though.

When Andy went into making films, I think that was really the
period in his life when he just decided to utterly re-do himself, and
he became a whole different person. There were a lot of people in
his life who he knew before, that didn't fit into that world very
well. I certainly didn't, and didn't want to. He was so different
that it was as though he couldn't be his old self any more.
Carl Willers, one-time lover.

The camera-work is lousy, the lighting's lousy, the sound is lousy ... but the people are beautiful.

The Empire State Building is a star. It's an eight-hour hard on. It's so beautiful. The lights come on and the stars come out and it sways. It's like Flash Gordon riding into space.
(On his film of the monument.)

How can I describe Andy Warhol? He's a genius. He has everything – good, bad, in between, lousy, terrible, shocking – in himself, so what do you want me to say? It's just like looking at life.
Julia Warhola, mother.

The best atmosphere I can think of is film, because it's three-dimensional physically, and two-dimensional emotionally.

I think movies should appeal to prurient interests. I mean, the way things are going now – people are alienated from one another. Movies should – uh – arouse you. Hollywood films are just planned-out commercials. *Blue Movie* was real. But it wasn't done as pornography – it was an exercise, an experiment. But I really do think movies should arouse you, should get you excited about people, should be prurient.

Bo Derek is the worst actress in the world … Couldn't even eat a banana on-screen in *Tarzan*. It was like she had no teeth.

When you read Genet you get all hot, and that makes some people say this is not art. The thing I like about it, is that it makes you forget about style and that sort of thing. Style isn't really important.

Andy Warhol is the worst, but most importantly influential artist of the period.
Norman Mailer.

I went to a party at Norman Mailer's house once, with Isabella Rossellini, Ingrid Bergman's daughter. She left her fur coat there. Norman didn't know whose coat it was so he gave it to his mother, who took it Florida. Isabella was so upset. It was a hand-me-down from her mother. So Mailer's mother was wearing Ingrid Bergman's coat in Miami Beach.

Andy was always a big help. He first invited us to The Factory to screen *Pink Flamingos*, because he didn't want to go to a crazed midnight show. Since he wasn't sure if he'd like it, he hid in the back until it was over and then came out. "You should make the exact same movie over again, exactly the same way," he told me. He later took Fellini to see it … I think Andy Warhol was really handsome. His obvious wig was the perfect answer to balding …
John Waters, director.

I think movies are becoming novels, and it's terrific that people like Norman Mailer and Susan Sontag are doing movies now too. That's the new novel. Nobody's going to read any more. It's easier to make movies. The kind of movies that we're doing are like paperbacks. They're cheaper than big books. The kids at college don't have to read any more. They can look at movies – or make them.

*To pretend something real, I'd have to fake it …
I don't know where the artificial stops and the real
begins.*

The Factory was a place where you could let your problems show, and nobody would hate you for it. And if you worked your problems up into entertaining routines, people would like you even more for being strong enough to say you were different and actually have fun with it.

I think we're a vacuum here at The Factory, it's great. I like being a vacuum – it leaves me alone to work. We are bothered though, we have cops coming up here all the time. They think we're doing awful things and we aren't.

The people I loved (to work with) were the leftovers of showbusiness, turned down at auditions all over town. They couldn't do something more than once, but their once was better than anyone else's. They had star quality, but no star ego – they didn't know how to push themselves. They were too gifted to lead regular lives, but they were also too unsure of themselves to ever become real professionals.

*When I look back, I can see that the biggest fights
at The Factory were always over the decorating.*

When you want to be like something, it means you really love it ... I love plastic idols.

Andy likes other people to become Andy for him. He doesn't want to be always in charge of everything. He would rather be me, or someone else sometimes. It's part of pop art, that everybody can impersonate somebody else – that you don't always have to be you to be you.
Nico.

The show left nothing to the imagination. We were on stage with bullwhips, giant flashlights, hypodermic needles and wooden crosses. It was very severe. It scared a lot of people.
Ronnie Cutrone, dancer.

The sound is a savage series of thrusts and electronic feedback. The lyrics combine sado-masochistic frenzy with free-association imagery. The whole sound seems to be the product of a secret marriage between Bob Dylan and the Marquis de Sade.
Contemporary review in the *Village Voice*.

With Dolly Parton.

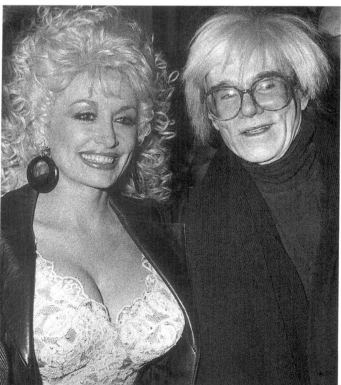

A girl always looks more beautiful and fragile when she's about to have a nervous breakdown.

Now and then someone would accuse me of being evil – of letting people destroy themselves while I watched, just so I could film them and tape record them. But I don't think of myself as evil – just realistic. I learned when I was little that whenever I got aggressive and tried to tell someone what to do, nothing happened – I just couldn't carry it off. I learned that you actually had more power when you shut up, because at least that way people will start to maybe doubt themselves. When people are ready to, they change. They never do it before then, and sometimes they die before they get around to it. You can't make them change if they don't want to – just like when they do want to, you can't stop them.

Warhol really fucked up a great many young people's lives. I was a good target for the scene. I bloomed into a healthy young drug addict.
Edie Sedgwick, socialite, underground actress, and eventual casualty.

With Nico.

Billy (at The Factory) used to say that amphetamine had been invented by Hitler to keep his Nazis awake and happy in the trenches, but then Silver George would look up from the intricate geometric patterns he was drawing with his Magic Markers – a classic speed compulsion – and insist that it had been invented by the Japanese so they would export more felt-tipped pens. Anyway, they both agreed that it hadn't been invented by any allies.

Some diet pills are made out of amphetamine, that was one reason speed was as popular with Society women in the sixties, as it was with street people. There were so many people from every level (using the drug), and although it sounds strange, I think a lot of it was because of the new fashions – everyone wanted to stay thin, and stay up late to show off their new looks at all the new clubs.

People on amphetamine didn't really have 'apartments', they had 'nests' – usually one or two rooms that held 14 to 40 people, with everyone paranoid that someone would steal their stash, or their only magenta Magic Marker, or let the water in the bathtub overflow into the pharmacy downstairs.

I could never finally figure out if more things happened in the sixties because ... so many people were on amphetamine ... or if more people started taking amphetamine because there were so many things to do.

You couldn't miss him, a skinny creep with his silver wig. His
appearance was far more conspicuous than it would be today. To
put it mildly I was not impressed. Andy asked me if I ever thought
about being famous. Andy would start off conversations like that.
It often made me feel vaguely uncomfortable. He said he wanted
to be as famous as the Queen of England. Here was this weird
cooley little faggot with his impossible wig and his jeans and his
sneakers and he was sitting there telling me that he wanted to be as
famous as the Queen of England! It was embarrassing. Didn't he
know that he was a creep? In fact he was about the most colossal
creep I had ever seen in my life. I thought that Andy was lucky
that anybody would talk to him.
Frederick Eberstadt, socialite.

There were so many crazy little girls who were in love with me,
and I never even talked to them. They were all on acid trips and it
damaged their brains and they never came back.

Tell the story of your life, and somewhere along the line take off
your pants.
(Directing one of his actors in *Chelsea Girls*.)

With *Chelsea Girls*, we showed two films simultaneously so, if the
audience got bored with one – they could watch the other.

I want to care, but it's so hard …

From the film *Flesh*.

I didn't expect the movies we were doing to be commercial. It was very heady to look and see our movie out there in the real world on a marquee, instead of in there in the art world.

Interviewing Warhol was like interviewing a chair.
Valerie Solanas, would-be assassin.

I didn't know Valerie very well. She was the founder of an organisation she called S.C.U.M. (Society for Cutting-Up Men). She would talk constantly about the complete elimination of the male sex.

I thought the title – *Up Your Ass* – was so wonderful, and I'm so friendly that I invited her to come up with it – but it was so dirty that I think she must have been a lady cop. We haven't seen her since, and I'm not surprised. I guess she thought that was the perfect thing for Andy Warhol.
(On turning down a film script, proffered by Valerie Solanas.)

From the film *Trash*.

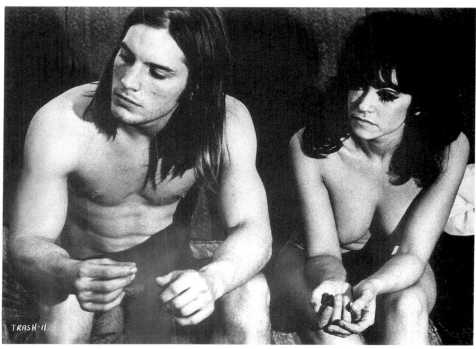

TRASH-11

 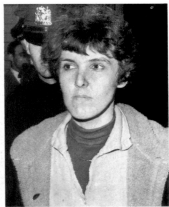

Valerie Solanas.

I said, No! No, Valerie! Don't do it! And she shot at me again. I
dropped down to the floor as if I'd been hit. I didn't know if I
actually was or not. I tried to crawl under the desk. She moved in
closer, fired again, and then I felt horrible, horrible pain, like a
cherry bomb exploding inside me. As I lay there I watched the
blood come through my shirt ... Later, a long time later they told
me that two bullets from a .32-calibre gun had gone through my
stomach, liver, spleen, oesphagus, left lung and right lung. It was
almost a half-hour before the ambulance got there.

They brought me back from the dead, literally, because I'm told
that at one point I was gone. For days afterwards, I wasn't sure if I
was back ... As I was coming down from my operation, I heard a
television going somewhere and the words 'Kennedy' and
'assassin' and 'shot' over and over again. Robert Kennedy had
been shot, but what was so weird was that I had no understanding
that this was a second Kennedy assassination – I just thought that
maybe after you die, they re-run things for you.

I look like a St. Laurent dress ... I've a lot of stitches.

I don't think that Valerie Solanas was responsible for what she did.
It was just one of those things.

Before I was shot I always thought that I was more *half* there than
all there. I always suspected that I was watching TV instead of
living life ... The movies make emotions look so strong and real,
whereas when things really do happen to you it's like watching
television – you don't feel anything.
Before (the shooting), I'd always loved being with people who
looked weird and seemed crazy – I'd thrived on it, really. Now I
was terrified that they would take out a gun and shoot me.

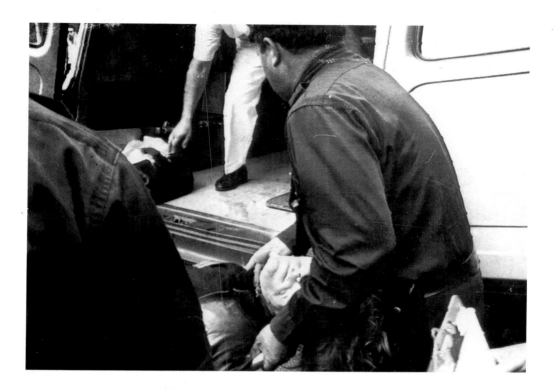

If I'd gone ahead and died, I would be a cult figure now.

I couldn't figure out why, of all the people Valerie must have known, I had to be the one to get shot. I guess it was just being in the wrong place at the right time.

I realised instantly that Valerie shot Andy out of love, and I understood her perfectly because I had felt the same thing. It was an intense reaction. You had a great emotion about Andy and, for some reason, you couldn't get close to him. He wasn't going to give you what you wanted. So I went away. She shot him.
Gretchen Berg, friend and journalist.

The Factory had always been open to any kind of person. Suddenly it was very difficult to come in. Video cameras were installed. You were screened. It had a very, very serious effect on his health and on his life. It left him very frightened.
Bianca Jagger.

In conversation with Paul Morrissey and Bianca Jagger:

Paul: Who are your favourite actors?
Bianca: I love Sir Laurence Olivier.
Andy: Don't you love John Belushi?
Bianca: I love Sir John Gielgud.
Andy: Who do you love under 70?

Bianca is such a tease. She's always going after guys and getting them all excited, giving them her phone number and then when they call not doing anything.

Andy liked to make you believe he was without depth or substance. He was flippant. It was his talent to make it all seem easy and superficial.
Bianca Jagger.

Mick, in a lime suit, came in with Jerry Hall. I thought things were fishy with Mick and Jerry, and then the plot started to thicken, of course. Mick was so out of it that I could tell the waiters were scared he'd pass out. His head was so far back and he was singing to himself. The top part of his body was like jelly, and the bottom half was tapping 3,000 taps a minute.

I met Andy in 1964 on my first visit to the United States. He introduced The Rolling Stones to the New York art and underground scene, and we stayed in touch until his death ... I thought the album cover he did for 'Sticky Fingers' was the most original, sexy and amusing package that I have ever been involved with.
Mick Jagger.

With Geri Miller who played Josie in *Pork*.

With Mick Jagger.

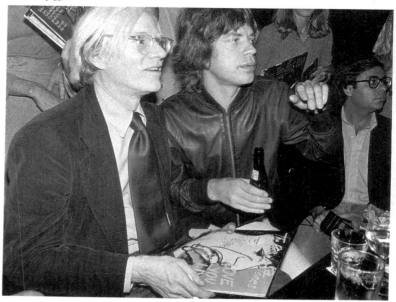

I think it's really a shame that Mick and Bianca have drifted apart. Bianca really is the girl of Mick's dreams because she's the female Mick Jagger. Having her over is just like having him over.

Halston and Bianca were in the kitchen together cooking, and he said he had so much energy he wanted to go dancing. He told me lots of gossip – he said that the night before when the doorbell rang, it was Liza Minnelli. Her life's very complicated now. Like she was walking down the street with Jack Haley, her husband, and they'd run into Martin Scorsese who she's now having an affair with, and Marty confronted her that she was also having an affair with Baryshnikov, and Marty said how could she. This is going on with her husband, Jack Haley, standing there! And Halston said that it was all true, and he also said that Jack Haley wasn't gay. You see? I was right, I didn't think so. Halston said Jack likes Liza but that what he really goes for is big curvy blonde women. So when the doorbell rang the night before, it was Liza in a hat pulled down so nobody would recognise her, and she said to Halston, "Give me every drug you've got." So he gave her a bottle of coke, a few sticks of marijuana, a Valium, four Quaaludes, and they were all wrapped in a tiny box, and then a little figure in a white hat came up on the stoop and kissed Halston, and it was Marty Scorsese, he'd been hiding around the corner, and then he and Liza went off to have their affair on all the drugs.

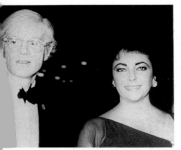

With Elizabeth Taylor.

Elizabeth Taylor has the best personality. She reminds me of my first 'superstar', Edie Sedgwick. Edie never grew up. Elizabeth is like a big kid too. She always says what she feels like saying. Just before she became a senator's wife she told me, "They'll never elect a man who's married to a woman who's been divorced five times. And *Jewish*."

One day during the 1976 election between Jimmy Carter and Jerry Ford, the *New York Times Sunday Magazine* section called and offered me an all-expenses-paid trip to Plains, Georgia. The catch was, I had to do a portrait of Jimmy Carter for their cover. Then the Carter people wanted me to make some prints that they could sell to raise money for the campaign. I decided to do it because, if he won, I knew I'd be invited to the White House a lot ... I spent most of the day in Plains taking pictures of men dressed as peanuts. Jimmy Carter gave me two big bags of peanuts, which he signed. That made the whole trip worthwhile.

I voted once, in the fifties. I don't remember which election. I pulled the wrong lever because I was confused. I couldn't figure out how to work the thing. There was no practice model outside. And then I got called for jury duty, and I wrote back 'Moved'. I've never voted again.

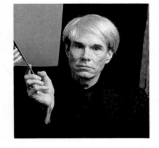

Mrs Trudeau was staying in the Japanese wing of the hotel. Japanese hotels have 'Western' rooms which look like Holiday Inn rooms only more orange, and Japanese rooms which are really nice if you don't mind sleeping on the floor ... I don't know what I expected Mrs Trudeau to be like, but it wasn't a breathtakingly beautiful young woman in a silk robe, sitting on the floor, blowing smoke rings into a rock garden. She said, "Hi Andy, you're the hardest person to reach in the world." I said, "They probably thought you were a hippie" ... It turned out that Mrs Trudeau had a laughing machine, the kind of thing you buy in a joke store, under her bathrobe. She said that she bought it to relieve the boredom of all the official events she had to attend. She would wear it under her proper 'First Lady' dresses and press her arm against it in the middle of some Japanese official's speech. The Japanese went crazy because they didn't know where the laughter was coming from. I knew we would be friends for life.

In conversation with Raquel Welch:

Andy: After Japan, New York is so super, I love it so much. Have you been to Japan ever?

Raquel: No, I haven't. Are they all trying to be Western in Japan? That's the impression I have.

Andy: Yes, but I love that. See, all the girls dress in Yves Saint Laurent, and they go to work, and everybody works – and I love that. Everybody's working there – it's like the United States in 1930 or something – they're all working and doing things and getting their laundry done in a half hour.

Raquel: What about the food? Is the food sensational?

Andy: Only when you pay 300 dollars a person.

Betty Ford was in New York for a benefit performance of a Martha Graham ballet, starring Nureyev and Fonteyn. Halston did the costumes, including Betty's. Afterwards Halston gave a party for the dancers and the kids who helped him with the costumes. Betty got wind of it and wanted to go, even though she wasn't invited because Halston didn't think it would be grand enough for her. I got to the house just before Betty Ford and her 20 Secret Servicemen. I was so nervous that I stashed my Brownies shopping bag – containing my tape recorder, camera, vitamins and candy – under a grey Ultrasuede banquette. That was just the banquette that Betty Ford decided to sit on! I had the worst time all night trying to figure out a polite way to get down on my hands and knees and ask the First Lady if I could get my tape recorder out from under her dress. Betty had such a good time that I didn't get my bag back till three a.m.

Watergate frightened me. I didn't know whether Nixon copied me or I copied Nixon. I had to stop taping for a while.

Warhol records everything. His portable tape recorder, housed in a black briefcase, is his latest self-protection device. The microphone is pointed at anyone who approaches, turning the situation into a theatre work. He records hours of tape every day, but just files away the reels – never listening to them.
Vogue profile.

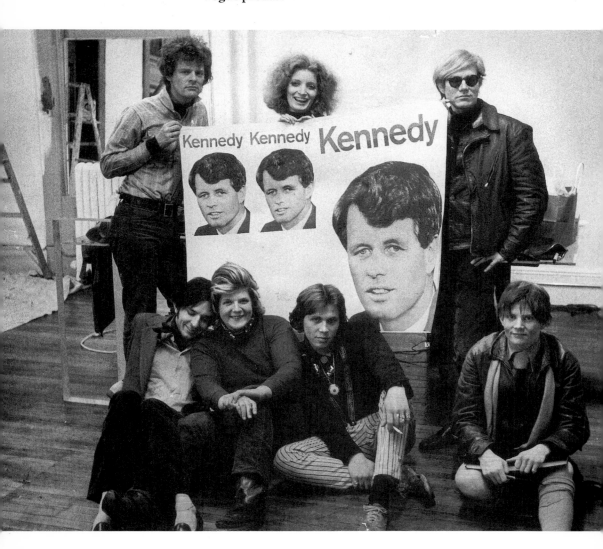

In the future everybody will be famous for 15 minutes.

When President Kennedy was shot, I heard the news over the radio while I was alone painting in my studio. I don't think I missed a stroke. I wanted to know what was going on out there, but that was the extent of my reaction. In a little while, Henry Geldzahler called up from his apartment and said that he'd been having lunch at the Orthodox Jewish restaurant where everyone from the Met and the NYU Art Institute always ate, and that the waiter had said in Yiddish, "De President is geshtorben," and Henry had thought he meant the President of the cafeteria. He was so affected when he found out that it was Kennedy that he went right home, and now he wanted to know why I wasn't more upset … I'd been thrilled having Kennedy as President, he was handsome, young, smart – but it didn't bother me much that he was dead. What bothered me was the way the television and radio were programming everybody to feel so sad. It seemed like no matter how hard you tried, you couldn't get away from the thing.

In conversation with Nancy Reagan, in The White House:

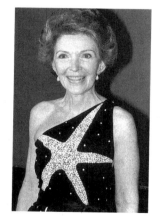

Andy: You know, I always thought they should have a lottery where they invite one family to dinner every night, because it's so exciting to be here.
Nancy: There are tours, of course, Andy.
Andy: But dinner is better.

I looked around the room and for miles all I could see were rich ladies in thousand-dollar dresses. There wasn't one charity case in sight. Then the show started. Maggie McNellis, the former radio and TV star, was the commentator. She kept everyone in stitches with unintentional jokes like, "Doesn't Ethel look pencil-thin in Galanos's new sheath of sequins." Meanwhile, Ethel Merman was barely making it down the runway, gasping for air in a dress she'd been poured into. Maggie's best line was when she introduced Jeanne Dixon, the famous psychic. "You all remember Jeanne," she said, "She's the one who warned President Kennedy not to go to Dallas." The whole place gasped. We headed for a restaurant. **(At a celebrity fashion gala, for charity, at the Waldorf-Astoria.)**

A good reason to be famous, is so you can read all the big magazines and know everybody in all the stories.

Everyone always reminds me about the way I'd go around moaning, "Oh when will I be famous, when will it all happen?" etc, etc, so I must have done it a lot. But you know, just because you carry on about something, it doesn't mean you literally want what you say. I worked hard and I hustled, but my philosophy was always that if something was going to happen, it would. If it wasn't and didn't, then something else would.

I can still walk down the street and not be recognised. If your picture's in the paper they know you the next day but, after that, they don't know you until your picture's in the paper again.

If I weren't me, I think I'd like to be Jackie Kennedy. She's a very glamorous woman, and I'd really like to learn some of her judo techniques.

My dog's stage name is Amos. Since his picture was in the *Daily News* and the *New York Post*, when I take him out people say, "Oh, look, there's Andy Warhol's dog."

With Geri Miller.

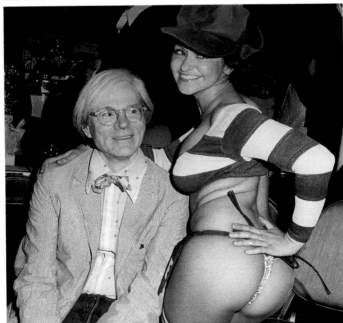

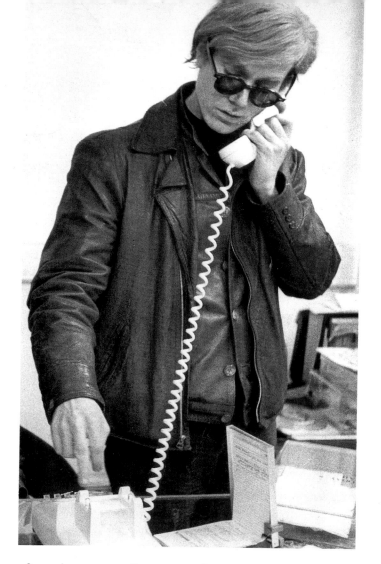

I can't see how I was ever 'underground', since I've always wanted people to notice me.

People asked why he was so famous. Every morning when he came to The Factory, he would go to the phone and call his press agent and tell him everything he had done. In those days a press agent cost 30 to 40 dollars a week. People were so naïve about fame. It was engineered in a purely business-like way.
Ronald Tavel, writer.

I have social disease. I have to go out every night. If I stay home one night I start spreading rumours to my dogs. Once I stayed home for a week and my dogs had a nervous breakdown ... I usually go out with one of the kids from the office, The Factory. Employees make the best dates. You don't have to pick them up and they're always tax-deductible.

The symptoms of social disease are various. You want to go out every night because you're afraid if you stay home you might miss something. You choose your friends according to whether or not they have a limousine. You prefer exhilaration to conversation, unless the subject is gossip. You judge a party by how many celebrities are there – if they serve caviar they don't have to have celebrities. When you wake up in the morning, the first thing you do is read the society columns. If your name is actually mentioned your day is made. Publicity is the ultimate symptom of social disease.

Warhol was the first American artist to whose career *publicity* was truly intrinsic. Publicity had not been an issue with artists in the forties and fifties. It might come as a bolt from the philistine blue – as when *Life* made Jackson Pollock famous – but such events were rare enough to be freakish, not merely unusual. By today's standards, the art world was virginally naïve about the mass media and what they could do. Television and the press, in return, were indifferent to what could still be called the avant-garde. 'Publicity' meant a notice in the *New York Times*, a paragraph or two long, followed eventually by an article in *Art News* which perhaps 5000 people would read. Anything else was regarded as extrinsic to the work – something to view with suspicion, at best an accident, at worst a gratuitous distraction. One might woo a critic, but not a fashion correspondent, a TV producer, or the editor of *Vogue*. To be one's own PR outfit was, in the eyes of the New York artists of the forties and fifties, nearly unthinkable – hence the contempt they felt for Salvador Dali.
Robert Hughes, critic.

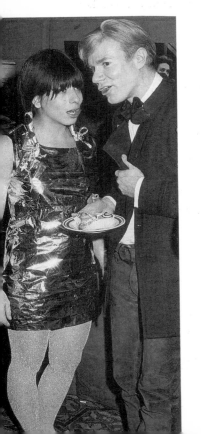

Publicity is like eating peanuts. Once you start you can't stop.

I can't give parties. It's so hard. When I want to call somebody up for dinner they think I'm using them or something. I just can't stand it.

Susan Blond pushed me into (Michael Jackson's) arms, and he was shy ... I shook his hand and it was like foam rubber. The sequinned glove isn't just a little sequinned glove, it's a catcher's mitt. Everything has to be bigger than life for the stage.

In conversation with Michael Jackson:

Michael: How could anybody eat this stuff? (trying a spoonful of caviar).
Andy: When you start taking your girlfriend out you're going to have to start eating all these things.
Michael: No!
Andy: Yes you are.
Michael: Not if I don't like it.
Andy: Listen, when I was in Iran I had it all day long.
Michael: Have you ever been to Disneyland? Did you like it?
Andy: Yes it's really great.
Michael: Do you have any kids?
Andy: Me? I don't believe in marrying.
Michael: Really? Why not?
Andy: I don't believe in love.
Michael: Really? You don't? You just date?
Andy: Yes, I like to date.
Michael: Do you live alone?
Andy: With my dogs. Do you live with your family? All of them? All nine?
Michael: Five of them are out.
Andy: Are they all married yet?
Michael: Four of them.
Andy: They'll probably have a lot of children too, right?
Michael: They may. You like children?
Andy: Ahh ... only if they're not mine.

I see a lot of Diana Ross since she's moved to New York, because she likes to go out – especially to Studio 54. I see Cher there whenever she's in town. Studio 54's where I see Liza too, and Lorna, and Lorna's husband Jake Hooker, and Lorna's dentist Allan Lazare, and Lorna's dentist's wife Arlene ... who looks a lot like Liza ...

Every time I go to studio 54, I'm afraid I won't get in – maybe there will be somebody new at the door who won't recognise me. Or my tie will be 50 per cent polyester without my knowing it. That's why I always go with Halston. He can get in in rayon.

I will go to the opening of anything, including a toilet seat.

Here are some tips on how to get into Studio 54. Always go with
Halston or *in* Halston. Get there very early or very late. Arrive in a
limo or a helicopter – one night Victor Hugo arrived in an
ambulance and got right in, he jumped off his stretcher and started
dancing. Don't wear anything polyester, not even your
underwear. And don't mention my name.

He was always fond of celebrities. He wanted to go to a lot of
parties, I mean, he met friends and he would say, "Well, take me
to this party, so-and-so's going to be there." He'd say, "I don't
care even if it costs me money, I wanna go! I wanna meet people!"
And he just kept on. It kept on building up. Later on they would
pay him to come to their parties.
Paul Warhola, brother.

I meet most rock stars through their girlfriends. Cindy Lang
introduced me to Alice Cooper, who reminds me of Salvador
Dali, except Dali doesn't drink beer and play golf.

Dali talks about Gala a lot. I think he's still madly in love with her
after all these years. He stole her away from Paul Eluard, the great
poet. It was one of the great surrealistic romances of the century.
All Dali's most beautiful paintings are of Gala. Sometimes I
wonder what he would have painted if he hadn't married her – and
his watch hadn't melted.

I got introduced to Meatloaf once, but we didn't hit it off. I called
him Meatball by mistake.

With Rupert Everett.

My friend Susan Blond arranged for me to see The Clash at the
Palladium ... On the way there Susan said, "They hate the rich,
they're worse than working class." Her husband Gary Kenton,
who is also a rock publicist added, "They're black collar." After
the show, we went backstage and I invited them to Studio 54. Paul
Simon was also backstage with Carrie Fisher. Bruce Springsteen
was there too ... The first person we ran into at 54 was a du Pont.
The second person we ran into was a Guinness. The third person
we ran into was Prince Albert of Monaco. The next day Joe
Strummer, the lead singer of The Clash, told Susan, "Last night I
did the three things I hate most in the world. I went with Andy
Warhol, in a limousine, to Studio 54. And you know what? I had a
great time."

I wanted to see Duran Duran at the Savoy because their video was
so good, 'Girls On Film'. When I got there the first band was still
on. Duran Duran are good-looking kids like Maxwell Caulfield.
And then afterwards they wanted to meet me so we went
backstage and I told them how great they were. They all wore lots
of make-up but they had their girlfriends with them from
England, pretty girls, so I guess they're all straight, but it was hard
to believe.

In the sixties there was always a party somewhere. If there wasn't a
party in a cellar, there was one on a roof, in a subway, on a bus, on
a boat, in the Statue of Liberty. People were always getting
dressed up for a party.

At this party Dylan was in blue jeans and high-heeled boots and a
sports jacket, and his hair was sort of long. He had deep circles
under his eyes and, even when he was standing, he was all
hunched in. He was around 24 then, and the kids were all
beginning to talk and act and dress and swagger like he did. But
not many people except Dylan could ever pull that anti-act off –
and if he wasn't in the right mood, he couldn't either ... I liked
Dylan.

Yoko Ono had this impromptu dinner for Bob Dylan ... and
everyone had to take their shoes off. Madonna arrived and said she
was so relieved her husband Sean (Penn) wasn't with her so she
could really have fun. And she felt uncomfortable without her
shoes because she didn't have socks – she said she'd feel more
comfortable with her top off than her shoes off.

With International Velvet (left) and Nico.

I like society hostesses. They make things happen, well, the good ones do. They spend all their lives arranging parties, deciding you should meet interesting people. I never ask anybody on a date. It's so hard to do that. I would spend all day thinking about how I was going to organise it.

I met Andy in the days when he was notorious for arriving with an entourage at parties only *he* had been invited to. Hostesses assumed he was rude, that he had no manners. But Andy in fact had very good manners, that was the problem. He was too polite to tell the kids who were dogging him to get lost.
Pat Hackett, Warhol's literary collaborator.

I haven't seen so many freaks in years.
(At a party given in his honour by Lord and Lady Lambton.)

Before going out in the evening ... I always go home first to change my shirt and have dinner with my dogs. They eat what I eat.

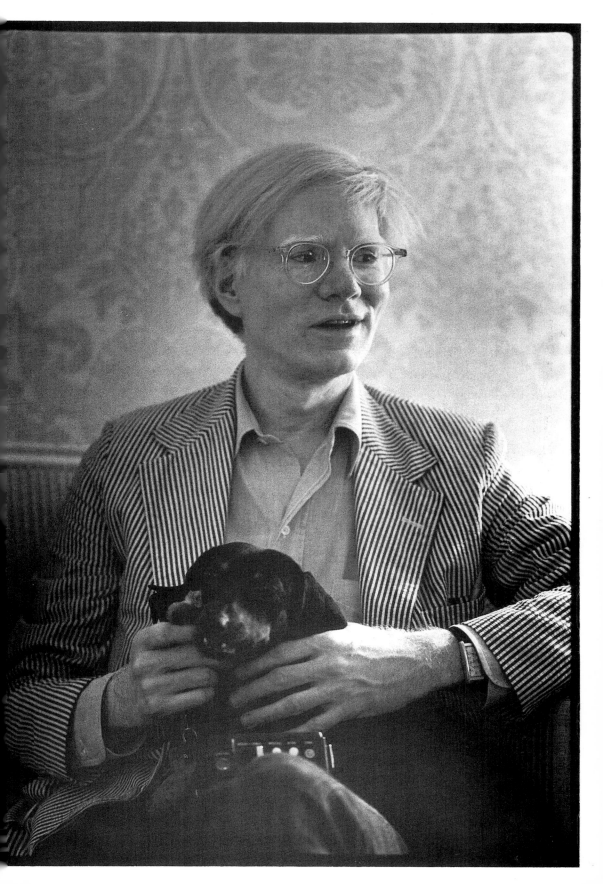

I went to see *Cats* ... The first act was so boring, but I noticed the pussies of the girls in the cat suits. I was revolted. You could see the slits up their fronts. They should really wear pads. And you could see the hair coming from their pussies, but then they also had cat fur put on there, so it was confusing. But oh, you could just see everything. Maybe that's why all these old men are going to the show.

As I always say, one's company, two's a crowd, three's a party.

You should have contact with your closest friends through the most intimate and exclusive of all media – the telephone. Before media there used to be a physical limit on how much space one person could take up by themselves. People, I think, are the only things that know how to take up more space than the space they're actually in, because with media you can sit back and still let yourself fill up space on records, in the movies, most exclusively on the telephone and least exclusively on television.

I remember getting a big mention on TV when Barbara Walters interviewed the Empress of Iran. In with the other art they did a big close-up of my Mick print and Barbara said, "And surprisingly they have a painting of rock star Mick Jagger by Andy Warhol," and the Empress said, "Oh I like to keep modern."

Certain people have TV magic. They fall completely apart off-camera, but they are completely together on-camera. They shake and sweat before they go on, they shake and sweat during commercials, they shake and sweat when it's all over. But while the camera is filming them, they're poised and confident-looking. The camera turns them on and off. I never fall apart because I never fall together. I just sit there saying, "I'm going to faint."

In the late fifties I started an affair with my television ... I played around in my bedroom with as many as four at a time. But I didn't get married until 1964, when I got my first tape-recorder. My wife ... the acquisition of my tape recorder really finished whatever emotional life I might have had, but I was glad to see it go. Nothing was ever a problem again, because a problem just meant a good tape, and when a problem transforms itself into a good tape, it's not a problem any more. An interesting problem was an interesting tape.

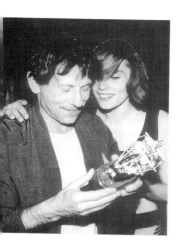

In conversation with Roman Polanski:

Roman: English television is fantastic, the best. The best! There's no commercials. Only one channel in England has commercials.
Andy: They're starting to have a lot more though. I like commercials.
Roman: Oh yeah?
Andy: Because I like it as a whole day. Watching for a day is like watching one movie, a one-day movie. Because you see news, and you see comedy, you see everything. And it's so great. And the commercials are just as beautiful and they're …
Roman: Well, I'm not particularly keen when in the middle of Othello, just after they've started – started to strangle Desdemona – they sell me Preparation H.
Andy: No! It's a breather. It makes it even more exciting!!

I loved the Miss Universe pageant … Miss USA was actually the best. She was from Hawaii and she looked like Jerry Hall, but when it came to the question, "What do you think of the United States," instead of saying something serious like, "It's the most free nation that glues together everything," she blew it by saying something like, "Oh, I love the beaches!" Miss South Africa won, she looked like a brunette version of Miss USA but she gave a serious answer, and Miss Colombia was too stoned to talk, ha-ha!"

If everybody's not a beauty, then nobody is.

With Jane Forth (left) and Joe Dallesandro.

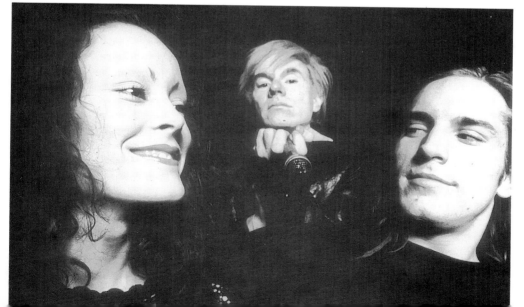

The best talk show I ever did, was in Japan. I didn't have to do anything. Just walked on and walked off. It was just a great show. Nothing happened. I didn't have to do anything. Gee, it was so good.

The John Lennon shooting was just so scary, I watched all the news on TV ... they always interview the janitors and the old schoolteachers and things. And the vigil outside the Dakota went on for so long. It looked so strange. I never know what those people think they're doing.

You know we were just at the Statue of Liberty celebration. The sun was out, it was a perfect day. The fourth of July. We were in a boat with millions of other people, and it felt like we were in a TV movie. Not even a real movie, but a TV movie.

I could never really describe the Diana Ross concert in Central Park. The sky darkened and the rain came, and it was the most incredible thing I've ever seen. Just the event of the century – her hair blowing and soaking wet, and if only they'd had a covering on the place where she was, she could have kept on singing, and the kids would have stayed, and she would have had her concert for TV. But they stopped it in the middle of the storm ... She was crying and (people) were trying to get her to stop, but she said she'd waited 20 years to do this. The lightning made it dangerous, I guess, but it was like a dream, like a hallucination, watching this spectacle. It was like the greatest scene from a movie ever. When they do her life story in the movies, you can just see this huge event, and then later she's crying and saying, "Why'd this happen to me?" and then drinking and slitting her wrists.

Holograms are going to be really great. You'll finally be able to pick your own atmosphere. They'll be televising a party, and you want to be there, and with holograms you *will* be there. You'll be able to have this 3D party in your house, you'll be able to pretend you're there, and walk in with the people. You can even rent a party. You can have anybody famous that you want sitting right next to you.

You're better off putting all your energy into your work. Sex takes up too much time.

From the film *Blood For Dracula*.

People's fantasies are what gives them problems. If you didn't have fantasies, you wouldn't have problems, because you'd just take whatever was there. But then you wouldn't have romance, because romance is finding your fantasy in people who don't have it. A friend of mine always says, "Women love me for the man I'm not."

Andy said, "*Harper's Bazaar* gave me a picture of Marlon Brando. Would you like to see it?" And I said, "Sure Andy, yeah" ... and he went into his pants, and he had it in there, and he showed the photo to me. Then he put it back in. And he was walking around New York with Brando in there!
Patrick S. Smith, friend.

Everybody has a different idea of love. One girl I know said, "I knew he loved me when he didn't come in my mouth."

There's nobody I ever want to be with particularly. My friends are everybody who's there in front of me.

I'm really afraid to feel happy because it never lasts.

I like especially his very sad paintings ... because sadness is truth.
Julia Warhola.

I always run into strong women who are looking for weak men to dominate them.

I've got these desperate feelings that nothing means anything. And then I decide that I should try and fall in love ... but then it's just too hard. I mean, you think about a person constantly and it's just a fantasy, it's not real, and then it gets so involved, you have to see them all the time – and then it winds up that it's just a job like everything else.

In conversation with Tatum O'Neal:

Tatum: Is it true that you've never fallen in love, Andy? I don't know why you'd never want to be in love. You can't help it when it happens, you're not in control.
Andy: Kids are the ones who fall in love.
Tatum: No, that's not true. You'll meet somebody. You'll have to get out of the crowd you hang around with. You'll meet her, I promise.
Andy: Where? In the subway?
Tatum: Don't you want to have a little Andy Warhol?
Andy: No.

I know a woman who calls somebody up every afternoon and says, "I'll pay you a hundred dollars to fuck me." Fabulous.

Sex is nostalgia for sex.

Truman (Capote) says he can get anyone he wants. I don't want anyone I can get.

Andy was always so provocative sexually. I think he knew that everybody was really thinking about big cocks, and he exposed that too. When people came to see him at The Factory, like foreign journalists or art dealers, he would say quite blandly, "Check him out, see how big his cock is," and these people would be horrified.
Ondine, Factory assistant.

My next series will be pornographic pictures. They will look blank. When you turn on the black lights, then you see them – big breasts. If a cop came in, you could just flick out the lights, or turn to regular lights – how could you say that was pornography? The thing I like about it is that it makes you forget about style. Style isn't really important.
(On a series that never happened.)

Because Andy was so shy and complexed about his looks, he had no private life. In filming, as in 'hanging out', he merely wanted to find out how 'normal people' acted with each other. And I think my own idea about *Blue Movie* (or *Fuck* as it had originally been called) wasn't, as I believed at the time, to teach the world about 'real love' or 'real sex', but to teach Andy.
Viva (Susan Hoffman), actress.

In conversation with Bette Midler:

Bette: Have you ever been to Hawaii?
Andy: Yes. As soon as you get off the plane it smells like sex.
Bette: Is that what your sex life smells like? Geee … Where've
you been hanging out?

It's great to buy friends. I don't think there's anything wrong with
having a lot of money and attracting people with it.

I think that being married is old-fashioned.

What we're all looking for is someone who doesn't live there, just
pays for it.

I think American women are all so beautiful, they're terrific. The
California look is great but, when you get back to New York,
you're so glad to be back – because they're stranger looking here
but they're more beautiful even.

From the film *Trash*.

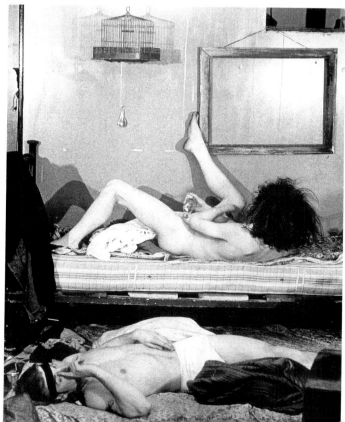

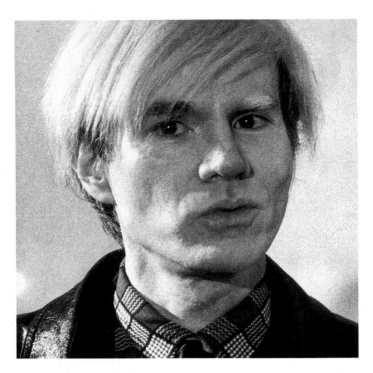

Everything is so glamorous in magazines ... Even all the sick people look glamorous in magazines.

Models all talk that baby talk, the girls and the boys. You always know when you're talking to a model.

I believe in low lights and trick mirrors. A person is entitled to the lighting they need.

I decided to go grey so nobody would know how old I was, and so I would look younger to them than how old they *thought* I was. I would gain a lot by going grey. Firstly, I would have old problems, which were easier to take than young problems. Secondly, everyone would be impressed by how young I looked. And thirdly, I would be relieved of the responsibility of acting young – I could occasionally lapse into eccentricity or senility, and no one would think anything of it because of my grey hair. When you've got grey hair, every move you make seems 'young' and 'spry', instead of just being normally active. It's like you're getting a new talent.

I wear the same clothes every day. I have a marvellous girl who fixes it so that, whenever I open the closet door, there is always a clean set of clothes ready.

At first I thought Andy never changed his shirt. I said, "I see you day after day in the same shirt." He said, "Oh no, I bought a hundred of them. I wear a new one every day."
Stephen Bruce, proprietor Serendipity cafeteria.

Second-hand clothes? . . . Oh no, I couldn't wear anything used.

I really do like fashion – not for me to wear, because it would take up too much of my time, but to look at on other people. I'm kinda keen about saving time up. I like furniture, really good furniture, but you have to spend time looking after it so I end up filling my house with things that nobody else wants.

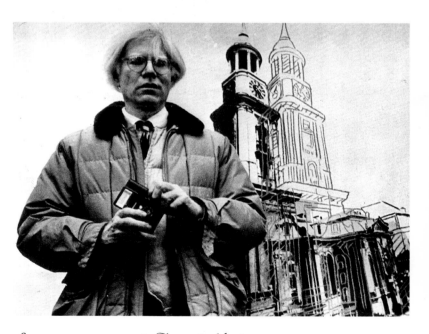

In conversation with David Hockney:

Andy: What do you think of the whole leather thing?
David: I used to think it never turned me on at all, but now I'm beginning to wonder, like rubber for instance. Some people get really excited by rubber.
Andy: Only English people.
David: Only the English? There are incredibly punky kids in London now. They are fantastic, but it's a bit violent. I don't really like the violence that much.
Andy: It's not *violent*. It's show-business.

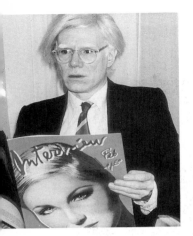

Who wants the truth? That's what show-business is for — to prove that it's not what you are that counts, it's what you think you are.

Andy made a virtue of his vulnerability, and forestalled or neutralised any possible taunts. Nobody could ever send him up – he'd already done so himself ... (We should) never take Andy at face value. The callous observer was in fact a recording angel. And Andy's detachment – the distance he established between the world and himself – was above all a matter of innocence and of art. Isn't an artist usually obliged to step back from things? In his impregnable innocence and humility, Andy always struck me as a 'yurodstvo' – one of those saintly simpletons who haunt Russian fiction and Slavic villages.
John Richardson, critic.

Journalists never want to know what you really think. They just want the answers that fit the questions, that fit the story they want to write.

The interviewer should just tell me the words he wants me to say and I'll repeat them. I'm so empty I can't think of anything to say. I'm not more intelligent than I appear. If you want to know all about Andy Warhol, just look at the surface of my films and my paintings and me, and there I am. There's nothing behind it.

I'm not the exhibitionist the articles try to make me out as.

I've been called complex, naïve, subtle and sophisticated – all in one article! They were just being mean.

In conversation with David Geffen:

Andy: I try to go around so often, so much, and try to go to every party so that they'll be bored with me and stop writing about me.
David: I don't think that works.
Andy: Yes it does. I'm not mentioned in a lot of magazines now.

I like being involved with *Interview* because it's a great way of meeting photographers and new people. There are so many new people around. These young girl models are so beautiful. It helps me a lot.

With Sylvia Miles.

We started the magazine *Interview* so we could get free tickets for
all the premières.

If you really planned them, the interviews could be so good. I'm
always so disappointed because, you know, you should really plan
a day for somebody, take them shopping or to the hairdresser and
tape their telephone calls. We did that with Bianca Jagger, it was
really exciting.

Dolly Parton came to the office to be interviewed. She was great
… She said she had a place in New York and goes out and around,
but I don't know how she can unless she puts another kind of wig
on. She talked non-stop for four hours. She's a walking
monologue.

Frank Zappa came to be interviewed for our TV show, and I think
that after the interview I hated Zappa even more than when it
started.

People kept bringing Woody Allen over to meet me, so I met him
four times … I can't stand Woody Allen movies.

I read the Ruth Kligman book *Love Affair*, about her 'love affair'
with Jackson Pollock. It's so bad – how could you ever make a
movie of it without making it a whole new story? ... In the book
she says something like, "I had to get away from Jackson and I ran
as far as possible." So do you know where she went? (laughs) Sag
Harbor. He lived in Springs. So that's what? Six miles? And she
was making it like she went to the other side of the world. And
then she said, "The phone rang – how, oh how did he ever find
me?" I'm sure she called hundreds of people to give them the
number in case he asked them.

They say that the article Caroline Kennedy did on the Elvis funeral
for *Rolling Stone* made fun of the local people, but I can understand
that. Caroline's really intelligent and the people down there really
were dumb. Elvis never knew there were more interesting people.

We waited while Jack Nicklaus talked on the phone. He looked fat
... and was very suntanned. But his eyes, around them, were
white where his sunglasses were, and his hands were tiny and
white – he wears gloves on the course. His hair was blond, and he
said something about needing a hair-cut, but I had the feeling that
his hair was just the way it always looked, puffed just-so over the
ears, like it was 'coiffed' ... I didn't know that golf clubs have hats
on them with drawstrings.

I'm so sick of the way I live, of all this junk, and always dragging
more home. Just white walls and a clean floor, that's all I want.
The only chic thing is to have nothing. I mean, why do people *own*
anything? It's really so stupid.

Andy found a lot of absurdity in the auction rooms. He loved the
absurdity of the art world just as he loved the absurdity of life in
general. At one point he noticed that pedestals for sculpture were
rarer than the sculptures themselves – so he started collecting
pedestals. "Anything looks good on a pedestal," he liked to say.
"Let's corner the market in pedestals."
Stuart Pivar, friend and shopping companion.

*Buying is much more American than thinking, and
I'm as American as they come.*

Switzerland is my favourite place now, because it's so nothing. And everybody's rich.

I am always looking for that five-dollar object that's really worth millions.

The rich have many advantages over the poor but, the most important one as far as I am concerned, is knowing how to talk and eat at the same time.

People are sleeping in pyramid-shaped spaces a lot now, because they think it will keep them young and vital and stop the ageing process. I'm not worried about that because I have my wings. However, my ideal too is the pyramid look, because you don't have to think about a ceiling. You want to have a roof over your head, so why not let your walls also be your ceiling, so you have one less thing to think about – one less surface to look at, one less surface to clean, one less surface to paint. The tepee-dwelling Indians had the right idea. A cone might be nice if circles didn't exclude the edges and if you could find the right round sink, but I prefer an equilateral-triangular pyramidal-shaped enclose even more than a square-based pyramid shape, because with a triangular base you have one less wall to think about, and one less corner to dust.

Andy liked to think that there was some kind of overall scheme, that the world was ruled by four people.
Fred Hughes, financial associate.

I'd be surprised if any of the many biographies are able to capture his peculiar temperament. He was not quite like anyone else.
Paul Morrissey.

I don't read much about myself. I just look at the pictures.

I don't think I have an image, favourable or unfavourable.

The world fascinates me. It's so nice, whatever it is. I approve of what everybody does. It must be right because somebody said it was right. I wouldn't judge anybody.

I don't think it matters how I'm appreciated, on many levels or just one.

The United States has a habit of making heroes out of anything and anybody, which is so great. You could do anything here.

It's true that I don't have anything to say, and that I'm not smart enough to reconstruct the same things every day – so I just don't say anything.

Bob Colacello (Andy's chief executive) makes everything work. On my own, just me, I couldn't get into or out of a hotel … I tend to worry more about providing one free copy of the new book we're promoting for a nice waiter, rather than worry about a hundred copies for people I've never met.

It wasn't really until the last few years of Andy's life that you would ever see him eat in restaurants. Andy would always eat at home before he went out. He was very careful and very prudent. **Fran Lebowitz, journalist.**

I used to have the same lunch every day for 20 years, I guess, the same thing over and over again. Someone said my life has dominated me – I liked that idea.

It's impossible to have lunch out in New York any more. It takes so long.

There are so many people in New York City to compete with, that changing your tastes to what other people don't want is your only hope of getting anything.

Everybody has their own America, and then they have pieces of a fantasy America that they think is out there but they can't see. When I was little, I never left Pennsylvania, and I used to have fantasies about things that I thought were happening in the Midwest, or down South, or in Texas, that I felt I was missing out on. But you can only live life in one place at a time. And your own life, while it's happening to you, never has any atmosphere until it's a memory. So the fantasy corners of America seem so atmospheric, because you've pieced them together from scenes in movies and music and lines from books. And you live in your dream America that you've custom-made from art and schmaltz and emotions, just as much as you live in your real one.

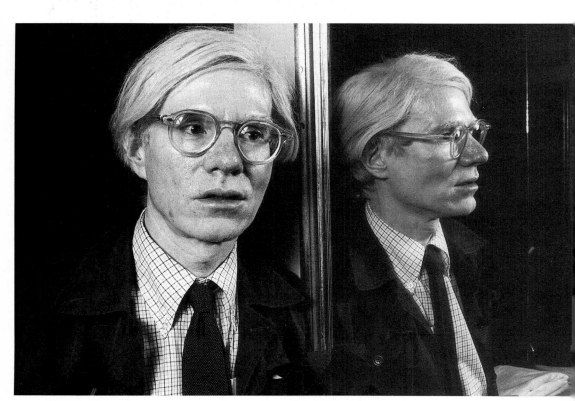

Everybody has problems but, the thing is, not to make a problem about your problem. For example, if you have no money and you worry about it all the time, you'll get an ulcer and have a real problem, and you still won't have any money – because people sense when you're desperate and nobody wants anything to do with a desperate person.

With Eleonora Giorgi at Xenon in New York.

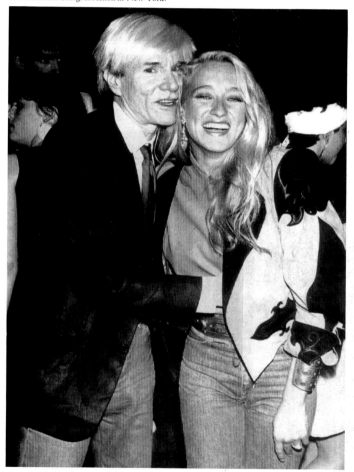

In conversation with Dustin Hoffman:

In conversation with Dustin Hoffman:
Dustin: When did they stop having conventional Easter Parades?
Andy: I think when they stopped wearing hats.
Dustin: Did they have one last year?
Andy: No, they haven't worn hats in a long time.

With Wayne County.

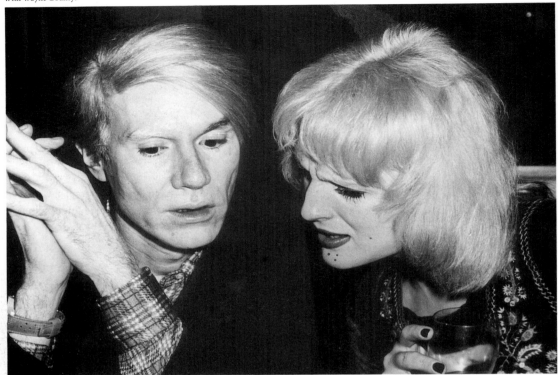

What *is* 'camp'?

Dustin plays it really straight in *Tootsie*. It's not like a drag queen, it's like having an aunt that you didn't know was a man.

Drag queens? The people we use aren't really drag queens, because drag queens are people who just sort of dress up for eight hours a day, or something like that. And the kind of people in our films are people who *think* they are really girls and stuff. So I think that's sort of different.

Everybody I know in New York pretends to be a fag. They work all day at being a fag, and then they run home at night to their wives.

A friend of mine always sends his socks to a very fancy East Side French Dry Cleaners, and they still come back with one missing. It really is a law – the diminishing return of socks.

I switch perfumes all the time. If I've been wearing one perfume
for three months, I force myself to give it up – even if I still feel
like wearing it. So whenever I smell it again, it will always remind
me of those three months. I never go back to wearing the same
one. It becomes part of my permanent 'smell' collection.

Andy Warhol? He's the only genius with an IQ of 60.
Gore Vidal, writer.

You should always have a product that has nothing to do with
who you are, or what people think about you. An actress should
count up her plays, a model should count up her photographs, a
writer should count up his words, and an artist should count up his
pictures. That way you never start thinking that your product is
you, or your fame, or your aura.

With Brooke Adams and Jerry Hall.

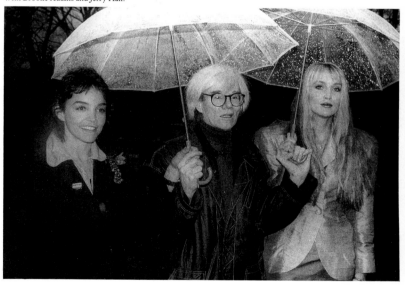

I like to be the right thing in the wrong space and the wrong thing
in the right space. But when you hit one of the two, people turn
the lights out on you, or spit on you, or write bad reviews of you,
or beat you up, or mug you, or say you're 'climbing'. But usually
being the right thing in the wrong space and the wrong thing in
the right space is worth it, because something funny always
happens. Believe me, because I've made a career out of being the
right thing in the wrong space and the wrong thing in the right
space, that's one thing I really do know about.

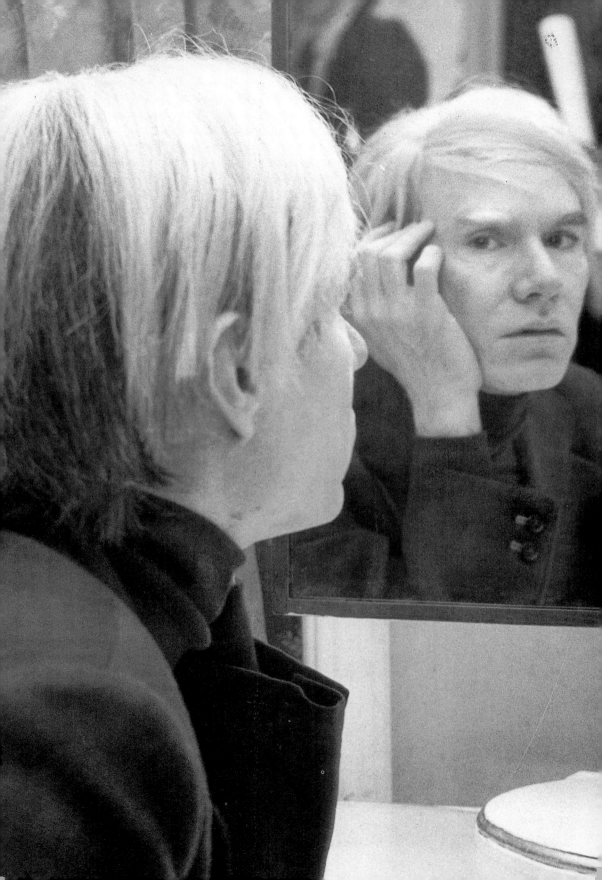

h Truman Capote.

The thing is to think of nothing ... Look, nothing is exciting, nothing is sexy, nothing is not embarrassing. The only time I ever want to *be* something is outside a party so I can get in.

I've always had a conflict because I'm shy, and yet I like to take up a lot of personal space. Mom always said, "Don't be pushy, but let everybody know you're around." I wanted to command more space than I was commanding, but then I knew I was too shy to know what to do with the attention if I *did* manage to get it. That's why I love television. That's why I feel that television is the media that I'd most like to shine in.

It's all entertainment. In painting or anything else, I've always just tried to do things that make people laugh.

Everything is beauty. Even being unattractive is beautiful.

Muscles are great. Everybody should have at least one they can show off.

With Sylvester Stallone.

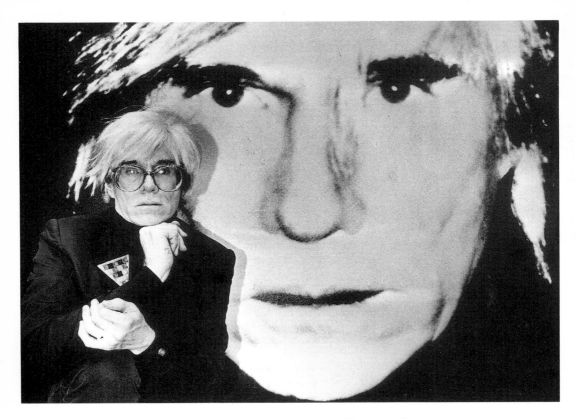

I paint pictures of myself to ... I guess, yeah, to remind myself that I'm still around.

I don't like looking at myself. It's hard to look at yourself. The self-portraits are just weird stuff. If it wasn't me in the pictures, the exhibition would be great ... I mean, when I walk in and see all these pictures looking back ... I don't look at me in the pictures, I just look at the images. When I was doing them I had to look at myself. I took a couple of hundred photographs and worked them over, and the ones that are the most worked over are the most vivid. It's a way of looking.

There are 16 (new self-portraits). There are variations in size, colour. With the camouflage. Without the camouflage. It's the same picture. It's from a polaroid. The same thing. Different sizes, different colours ... Why? I dunno. I always thought I should have done the same painting – but I changed subject matter, when I should have just kept painting the same, you know, Campbell's soup can number ... over and over and over. It would have been easier. People just remember me for the soup cans anyway. No, that's good, I like that ... When I go to the supermarket, it's the same can. They were going to change it, I think, but they didn't do it. Campbell's asked me to do their new box. The dry soup. It was a painting of a box.

Everything is more glamorous when you do it in bed ... Even peeling potatoes.

I went to China. I didn't want to go, and I went to see the Great Wall. You know, you read about it for years. And actually it was great. It was really really really great.

The lobbies are always the best looking places in the hotel. Compared with the lobby, your room always looks like a closet.

What makes a person spend time being sad when they could be happy?

It's kind of funny what makes people comfortable. I like movies, but I can't enjoy anything in a crowded cinema, so I go to screenings in small private movie theatres.

Life and living influence me more than particular people.

I delight in the world. I get great joy out of it, but I'm not sensuous. I've heard it said that my paintings are as much a part of the fashionable world as clothes and cars. I guess it's starting that way, and soon all the fashionable things will all be the same. This is only the beginning, it'll get better and everything will be useful decoration. I don't think there's anything wrong with being fashionable or successful. As for *me* being successful, well, it just gives you something to do, you know?

I don't feel my position as an accepted artist is precarious in any way. The changing trends in art don't frighten me, it really just doesn't make any difference. If you feel you have nothing to lose, then there's nothing to be afraid of, and I have nothing to lose. It doesn't make any difference that I'm accepted by a fashionable crowd – it's magic if it happens and, if it doesn't, it doesn't matter. I could be just as suddenly forgotten, it doesn't mean that much. I always had this philosophy of "It really doesn't matter." It's an Eastern philosophy more than Western. It's too hard to think about things. I think people should think less anyway. I'm not trying to educate people to see things or feel things in my paintings. There's no form of education in them at all.

I don't actually like my paintings very much. I don't hang them in my house. I'd rather go out and buy very simple American primitives. They're really nice to live with.

What survives (of art) is what the taste of the ruling class of the period decrees *should* survive, and this turns out to be the most effective work done within the canons and terms *of* that class.

You need a good gallery so the ruling class will notice you.

Everything is art. You go to a museum and they say *this* is art – and the little squares are hanging on the wall. But everything is art, and nothing is art. Because I think everything is beautiful – if it's right.

Motor cycle gang leaders are fantastic … they're the modern outlaws. I don't even know what they do … What *do* they do?

Why did my *Athletes* exhibition only show head-shots? Well, I'm not very good at painting bodies.

Athletes are going to be the new media stars – more intelligent and more beautiful than movie stars, and even bigger than rock stars.

In conversation with Jodie Foster and her mother, Brandy:

Andy: You're not a corporation are you?
Jodie: I have no idea. Mom bothers with that end of it. I'm not a corporation am I?
Brandy: She was.
Andy: I was, too.

With the business in New York, we can actually take everything off as expenses, deduct things. I take my dog off. I've put my dog in movies and deducted my dog.

I love animals. I once had 26 cats.

I don't care. I don't care about anything. That's what my work is all about.

Warhol made his own lifestyle a work of art. He was one of the first people to really become a star as an artist and, once celebrity came, he really enjoyed it.
Richard Oldenberg, director of the Museum of Modern Art in New York.

I don't eat or drink anything in the mornings, because I've usually had at least three dinners the night before.

I really do live in the future because, when I'm eating a box of candy, I can't wait to taste the last piece.

I want to start a chain of restaurants for other people who are like me – 'The Restaurant For The Lonely Person'. You get your food, then you take your tray into a booth and watch television.

Other people have more things to say than I do. I don't really have anything to talk about.

When I'm really impressed, I get so nervous I can't talk. Fortunately most of the people who work for me get so nervous they can't stop talking.

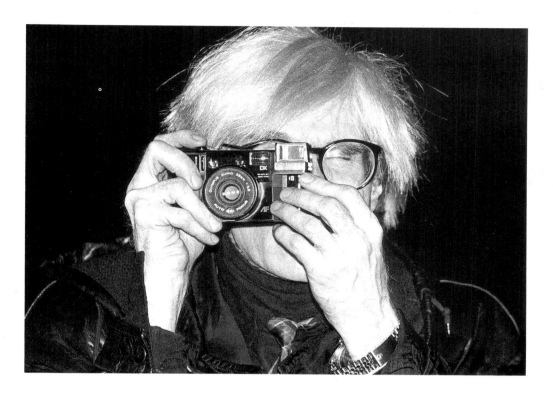

What would I do if I were President? Oh, I'd put carpets in the streets.

As a friend he was fabulous, as a force he was formidable.
Liza Minnelli.

Wolfe is right. It's true. Nobody knows anything about these things unless someone writes about them.
(On Tom Wolfe, whose book *The Painted Word* criticises the conspiracy of art theorists, without which, artistic movements would be meaningless.)

Art is short for artist. Paintings are just to cover up the wall. Art is entertainment and pleasing people.

The primary creation of Andy Warhol is Andy Warhol himself.
Harold Rosenberg, art critic.

Try the Andy Warhol New York City Diet. When I order in a restaurant, I order everything that I don't want.

Being clean is so important … It doesn't matter what they're wearing or how much their jewellery costs – if they're not clean, they're not beautiful.

If a person isn't generally considered beautiful, they can still be a success if they have a few jokes in their pockets. And a lot of pockets.

London must be depressed. All the young London freeloaders have come to New York. All the English here seem to have come out of *Brideshead* – young, broke and mixed up. If I go to London they've all got titles, but no money. That's why they're here. We're into youth in New York.

I used to eat a Campbell's soup lunch every day for 20 years. Now I hate the stuff. I've become a nutritionalist.

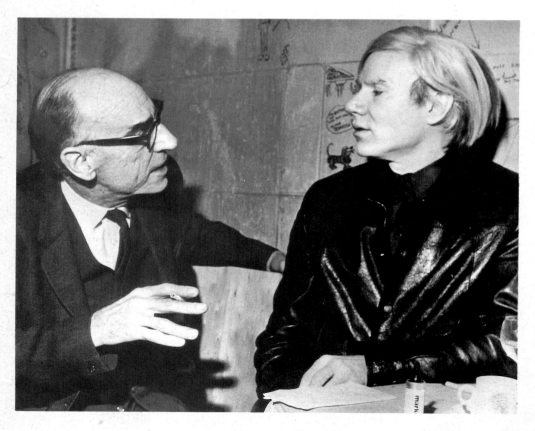

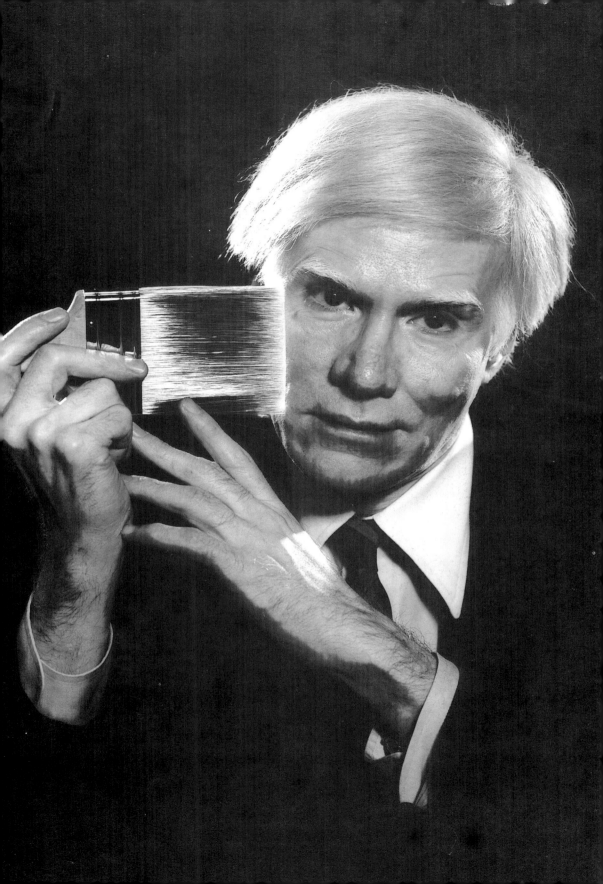

Once I was in Paris and I was invited for tea to meet Cloda Colber, Simone Simone, Olivia de Havilland and Ginger Rodgers, and I was so surprised because they were all so short, but they had big heads. Or they had big heads and they were all so small. Their bodies were short. Their heads were big, and I never realised that that's the reason why some of the Hollywood stars were so great – because on screen they all came out so much better. Tall people never really make it so well as short people. Er, except cover girls, but they don't have to move around quite so much.

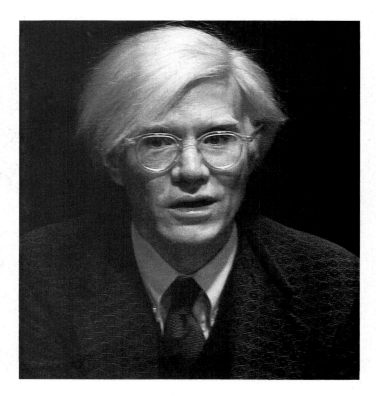

In conversation with Ginger Rogers:

Ginger: We sort of hit the papers all over.
Andy: Oh, I know – the Christian Science Monitor.
Ginger: No, every paper.
Andy: Yes but that was our favourite.
Ginger: But we hit every paper. In fact, there were three or four different photographs of the same moment.
Andy: I liked it because everyone's eyes were going in a different direction.

I like the eighties, everybody is caring again. Hands across America. We went out and raised money for the Salvation Army, just standing on the corner. The people who could afford it didn't give us any. The people who looked as if they couldn't, gave.

Andy takes part in Hands Across America with Yoko Ono (far left) and friends.

The other day I went with Yoko Ono to Harlem, to an adopting centre. I forget what it's called. It was a really interesting thing. There's 17,000 babies to be adopted. You can just walk in and adopt a baby. You can be a single parent. That's what's so good about this place. I guess I would adopt one if I could think about what to do to look after it. The dogs, Fame and Fortune, they're mine, but somebody else looks after them for me.

So many people's lives were touched by Andy in a very special way. **Yoko Ono.**

With Keith Haring and Sean Lennon.

I don't like big moments, weddings, anniversaries, *funerals*. I like to play things all at the same level. When you run into somebody you haven't seen in 20 years, the best thing is when you both play it cool, very American, don't get excited, don't try to catch up. Maybe mention you're on your way to a movie – they'll tell you they're on their way to dinner – but just be off-hand. Just play it like it's no big deal, like you just saw them yesterday and like you'll be seeing them all again tomorrow.

'Heaven And Hell Are Just One Breath Away'.
Reputedly the title, and subject, of Warhol's final work – a piece of graffiti art.

Billboard artist Greg Puchalski in front of his work honouring Andy.

When I die I don't want to leave any left-overs. I'd like to disappear. People wouldn't say he died today, they'd say he disappeared. But I do like the idea of people turning into dust or sand, and it would be very glamorous to be reincarnated as a big ring on Elizabeth Taylor's finger.

Andy Warhol fooled the public into believing his only obsessions were money, fame and popularity. Never take Andy at face value. **John Richardson.**

I never think that people die. They just go to department stores.

I switch to another channel in my mind, like on TV. I say, "She's gone to Bloomingdale's."
(Explaining how he coped with the death of his mother.)

Why, this is really marvellous. I mean, if a person were dying he could photograph his own death.
(On the discovery of a remote-control camera.)

The proper quality of medical care and treatment was not maintained in this case.
The New York State Health Department's accusation, following Andy's surprise death.

You can never be sure about death … because you're not around to know that it has happened.

Andy would have loved this event. He planned it. He foresaw *all* this happening.
Stuart Pivar, on Sotheby's multi-million dollar sale of Warhol's possessions.

I never understood why when you died, you didn't just vanish, and everything could just keep going the way it was only you just wouldn't be there. I always thought that I'd like my own tombstone to be blank. No epitaph, and no name. Well actually, I'd like it to say 'Figment'.

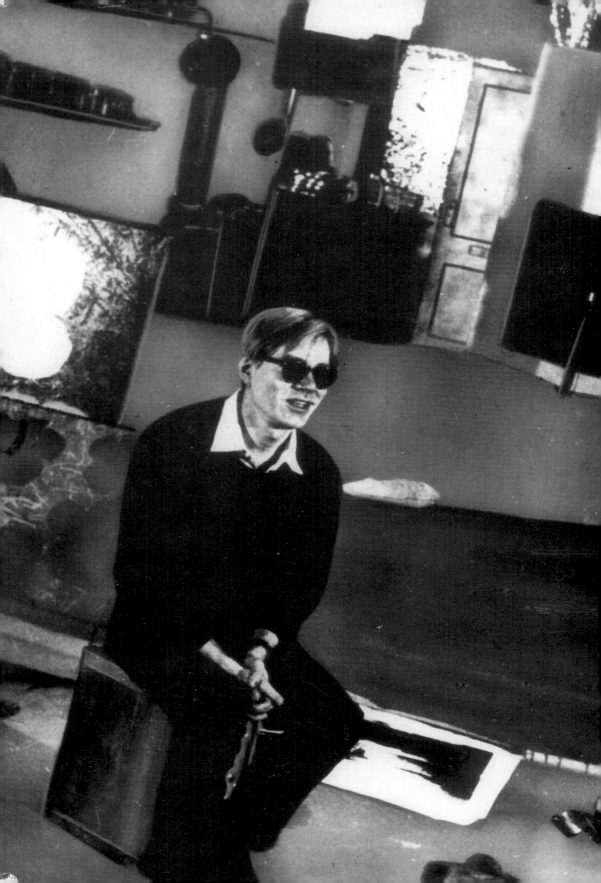